BEATRIX POTTER ™

COLORING BOOK

FREDERICK WARNE
An Imprint of Penguin Random House LLC

FREDERICK WARNE
Penguin Young Readers Group
An Imprint of Penguin Random House LLC

First published in the United Kingdom in 2016 by Frederick Warne.
First published in the United States of America in 2017 by Frederick Warne, an imprint of
Penguin Random House LLC, 345 Hudson Street, New York, New York 10014.

Manufactured in China

ISBN 9780141377483

10 9 8 7 6 5 4 3 2 1

THIS BOOK BELONGS TO

..

THINGS TO FIND

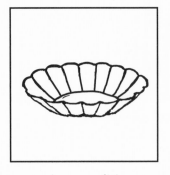

An empty dish

An inquisitive mouse

A flickering flame

A watering can

A business mouse

A ladybug

A resting iron

A missing shoe

A fly

A stylish hat

A curtseying mouse

A perching robin

Peter Rabbit, Benjamin Bunny, Jemima Puddle-duck,
and so many more timeless characters await your
arrival in the enchanting world of Beatrix Potter.
Rediscover the magic of the natural world with this intricately
illustrated coloring book featuring quotes from the original tales.

Inside this book you will find delightful illustrations of
Beatrix Potter's charming characters. Add color to bring them to life
and explore the pages to find the items listed on the opposite page.

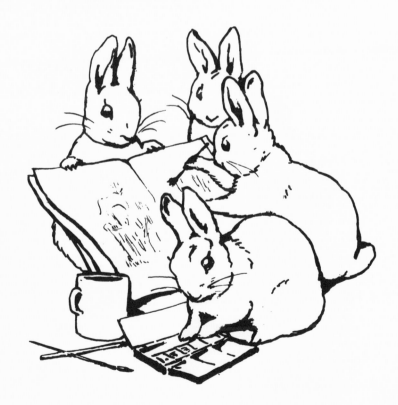

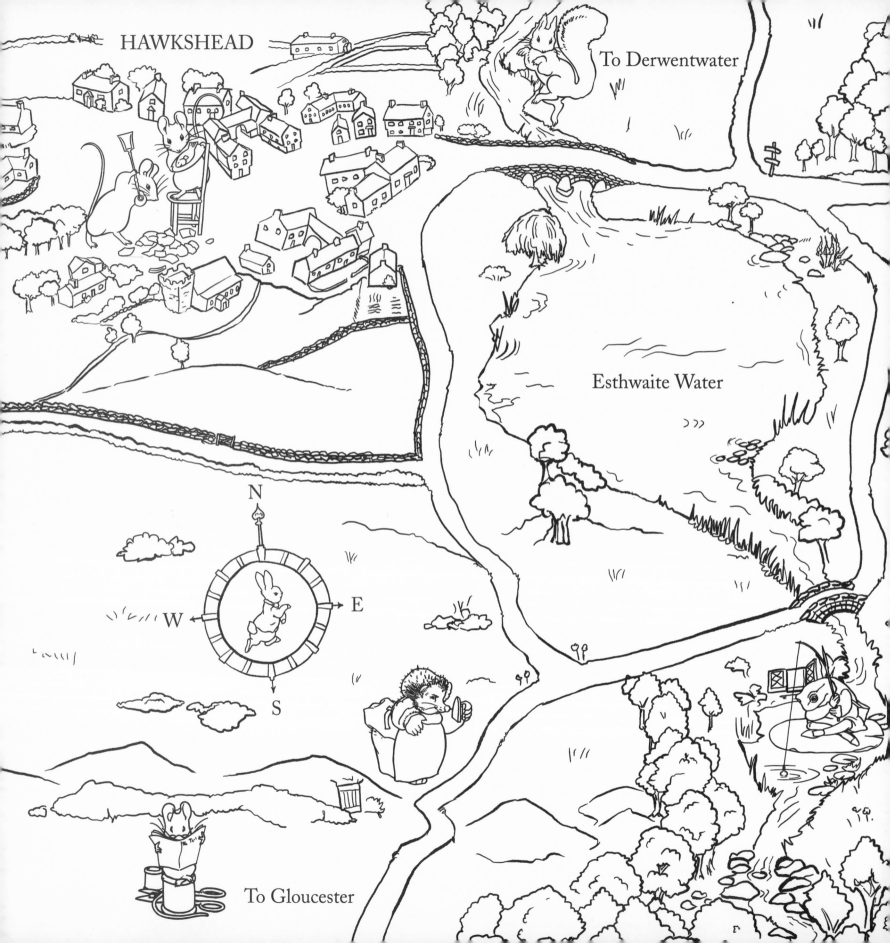

HAWKSHEAD

To Derwentwater

Esthwaite Water

N

W E

S

To Gloucester

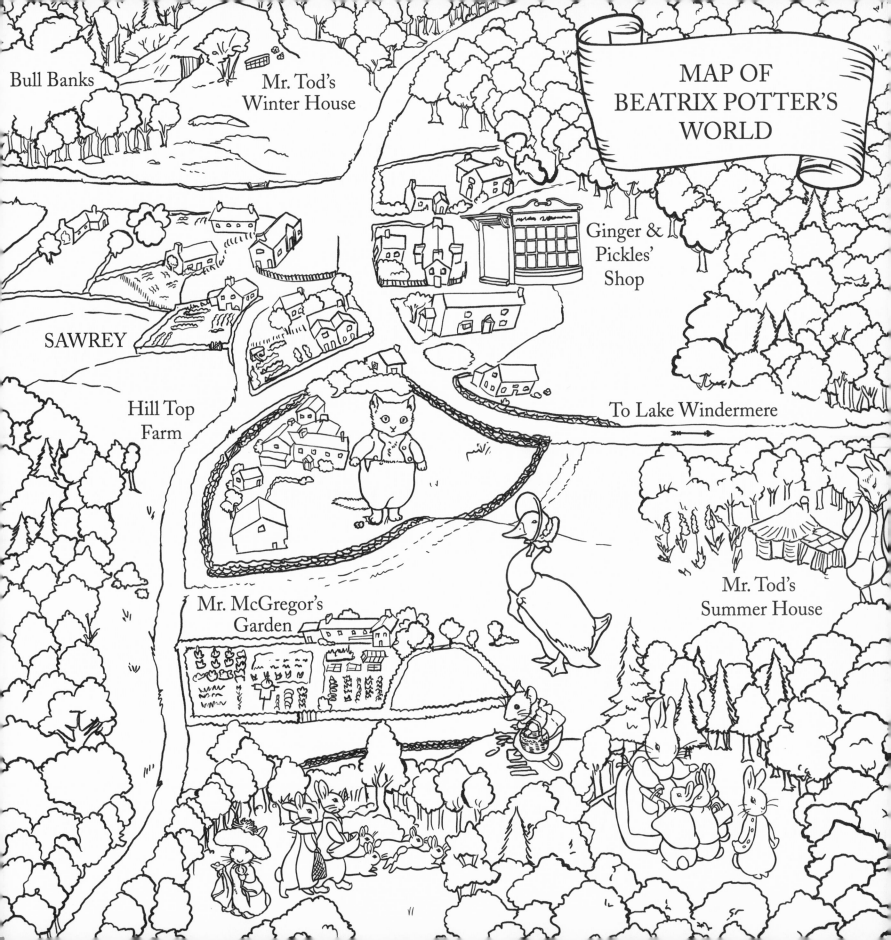

Bull Banks

Mr. Tod's
Winter House

MAP OF
BEATRIX POTTER'S
WORLD

Ginger &
Pickles'
Shop

SAWREY

Hill Top
Farm

To Lake Windermere

Mr. Tod's
Summer House

Mr. McGregor's
Garden

Map of Beatrix Potter's world

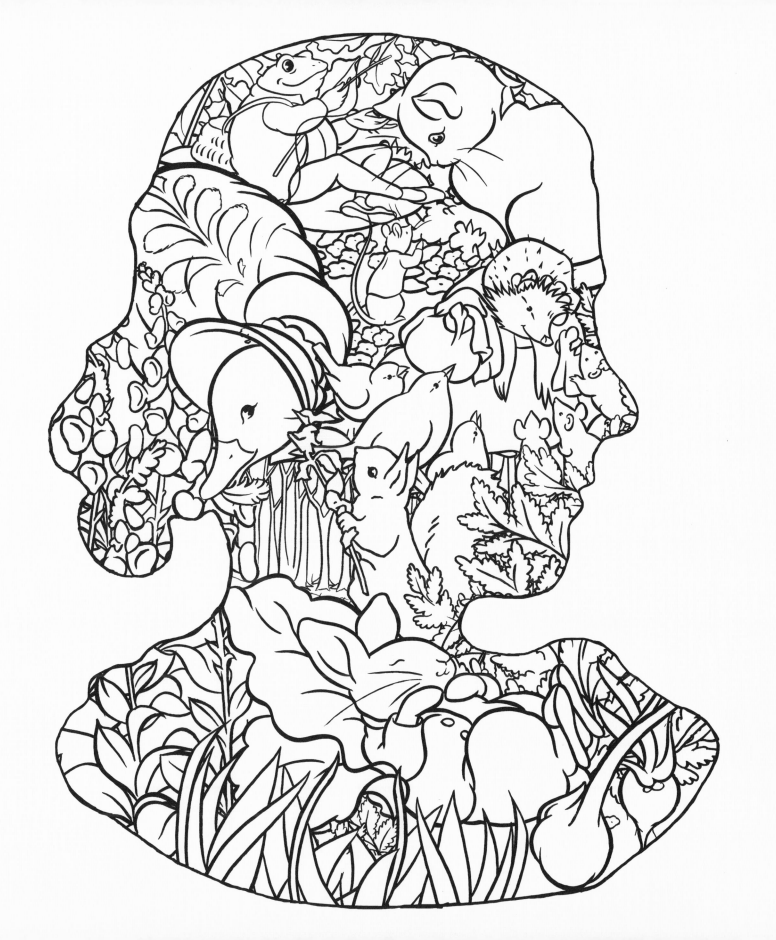

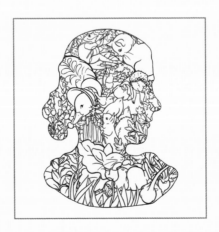

The imagination of Beatrix Potter

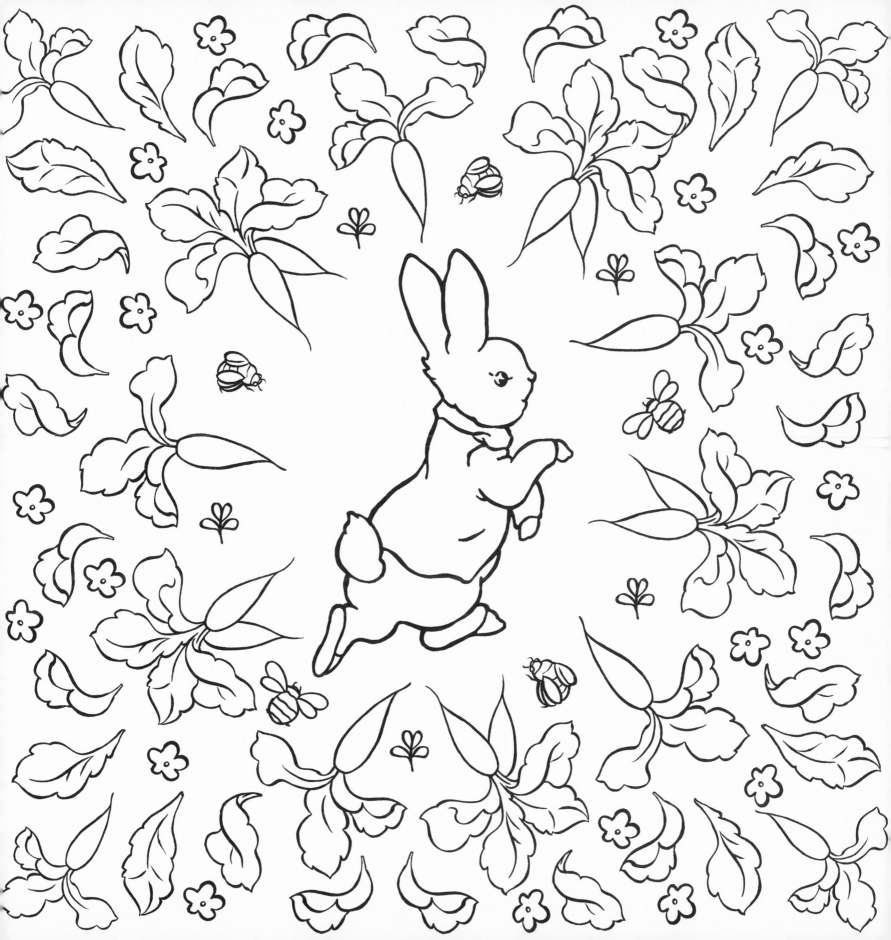

Peter Rabbit

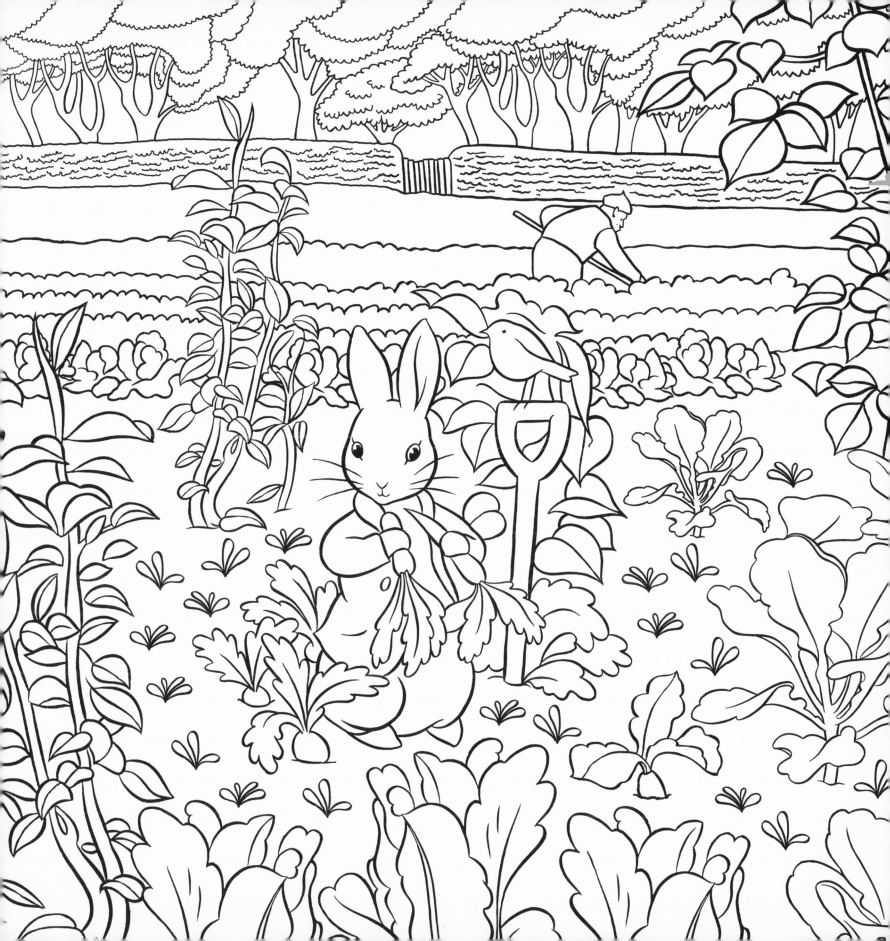

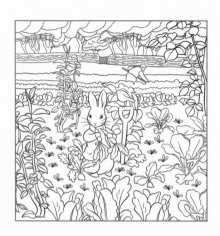

In Mr. McGregor's garden

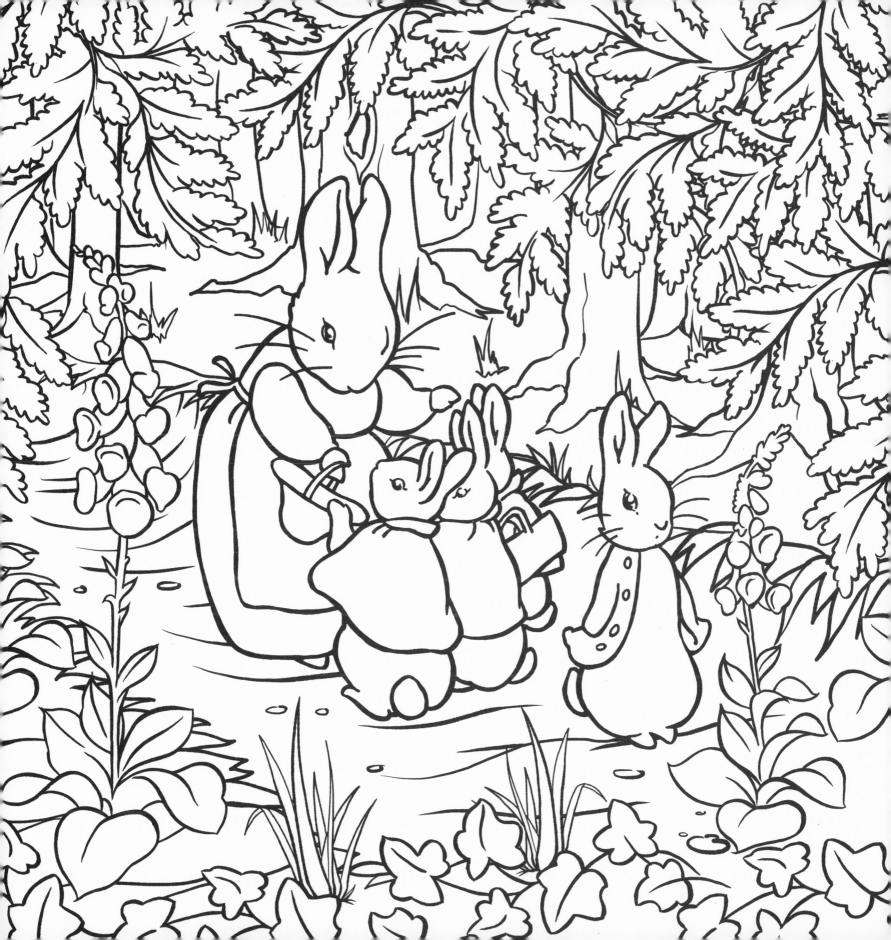

"Once upon a time there were four little Rabbits . . ."

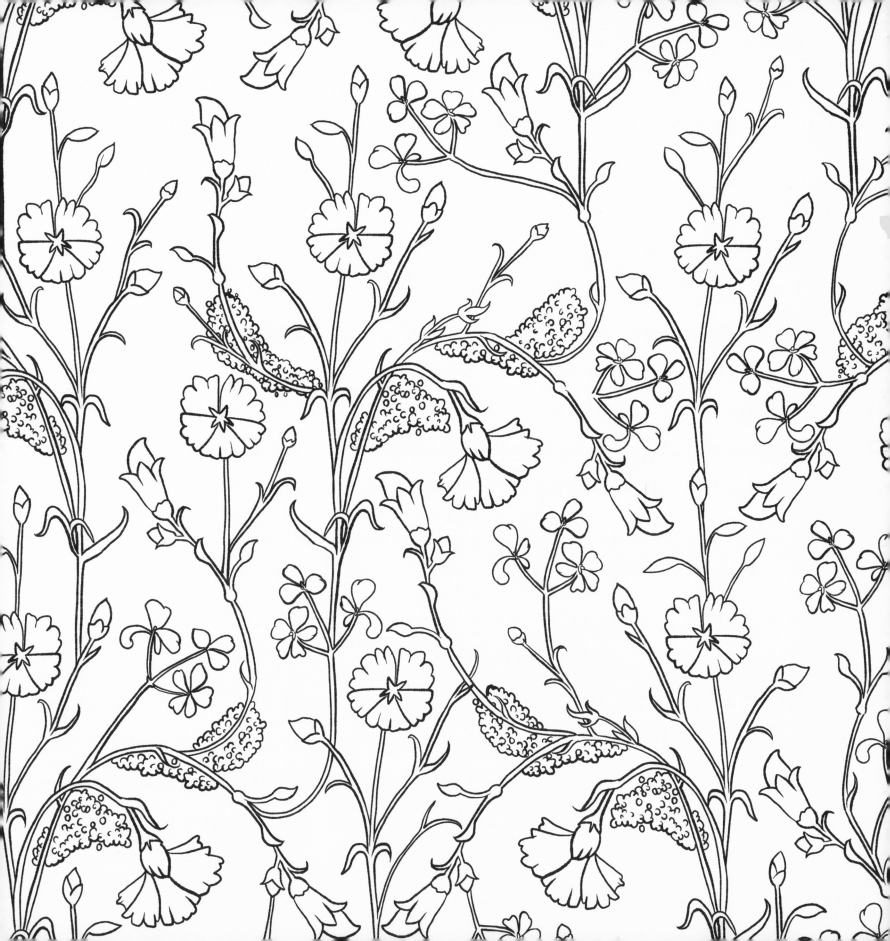

Carnations and geraniums

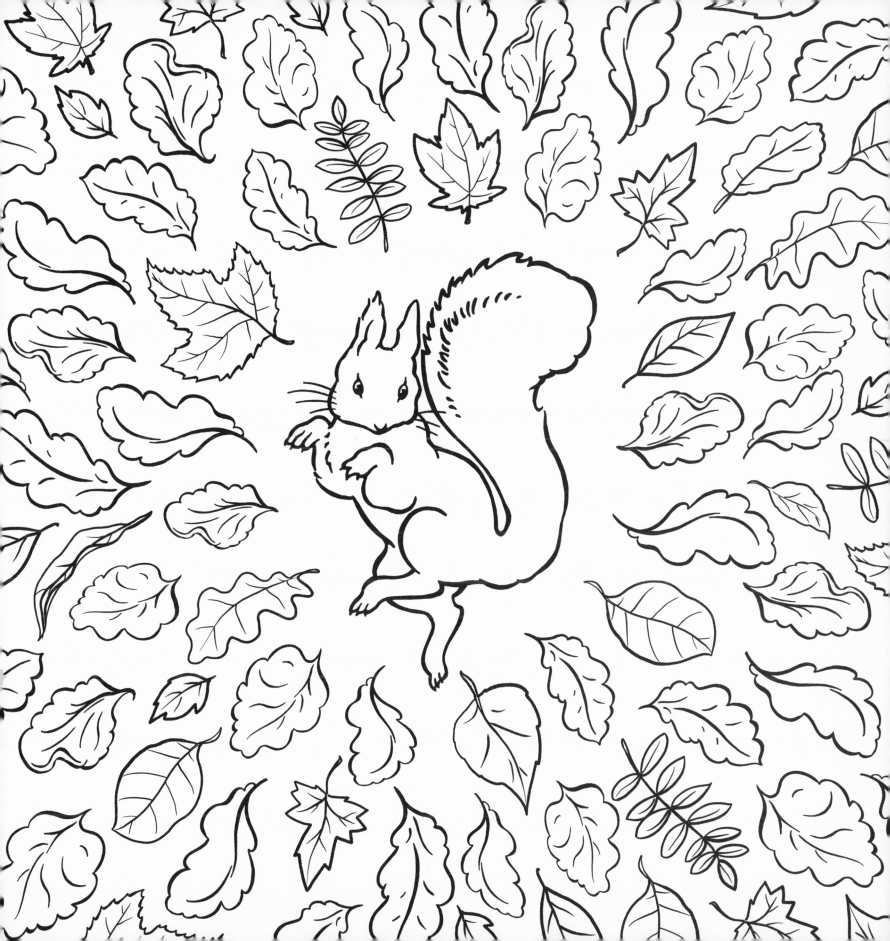

Squirrel Nutkin

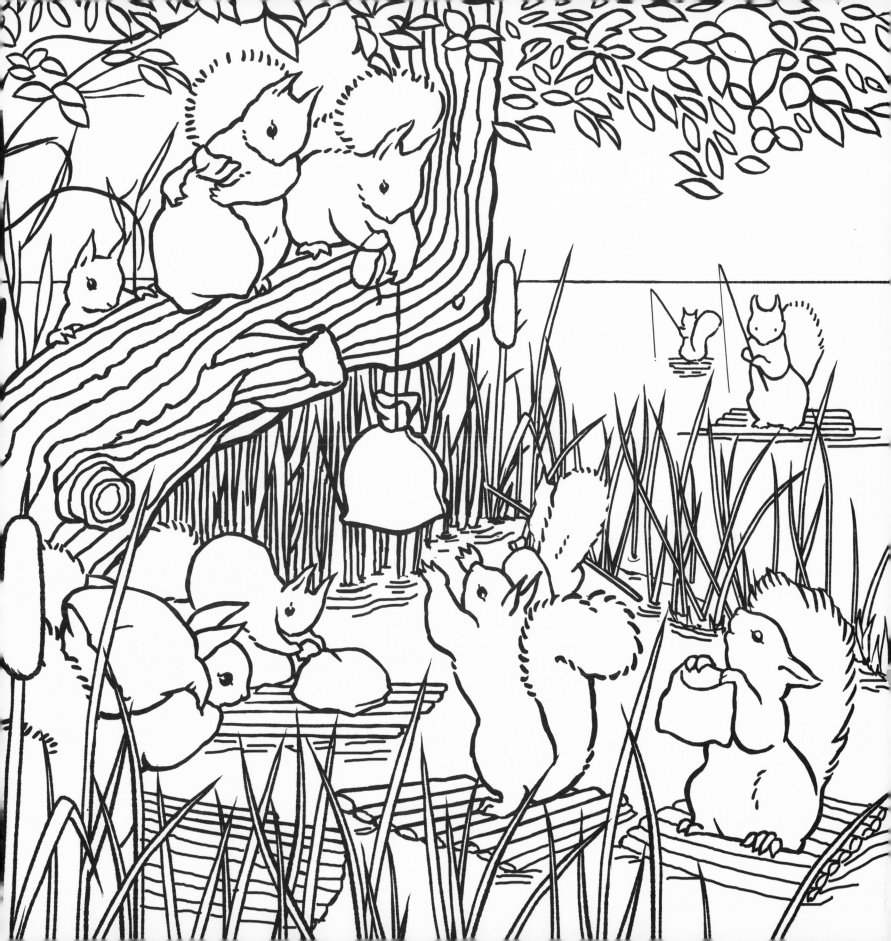

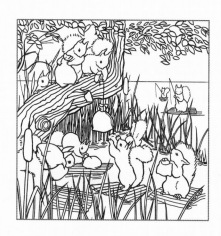

Sacks filled with nuts

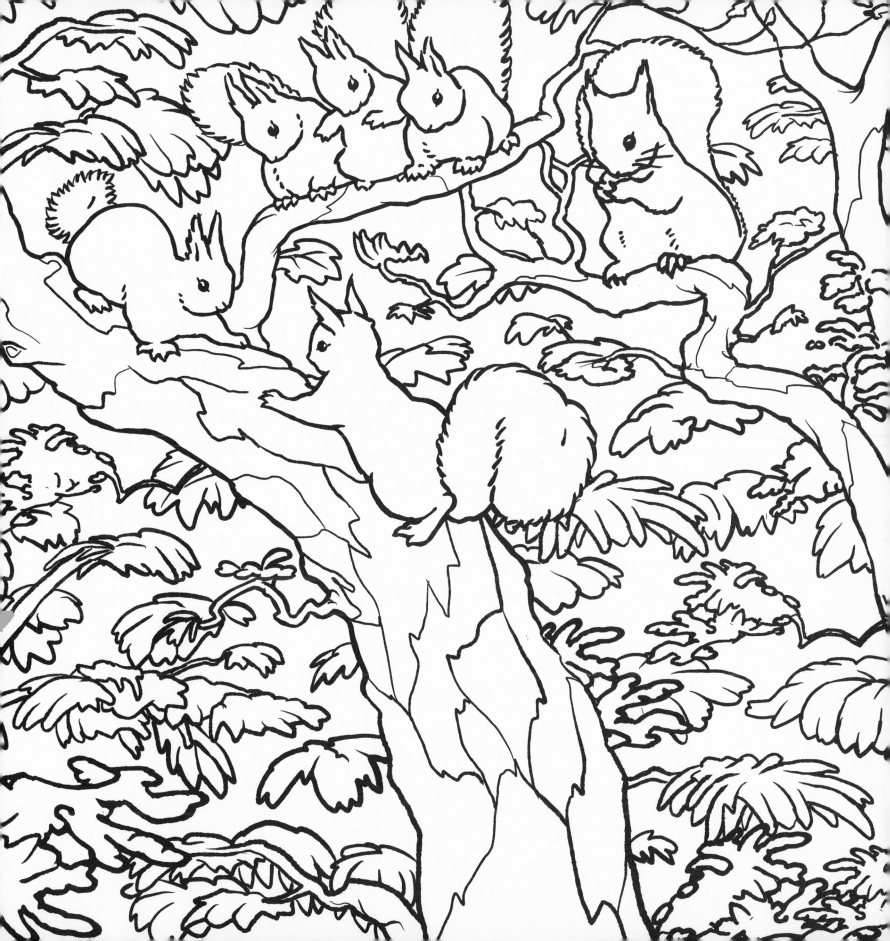

"This is a tale about a tail . . ."

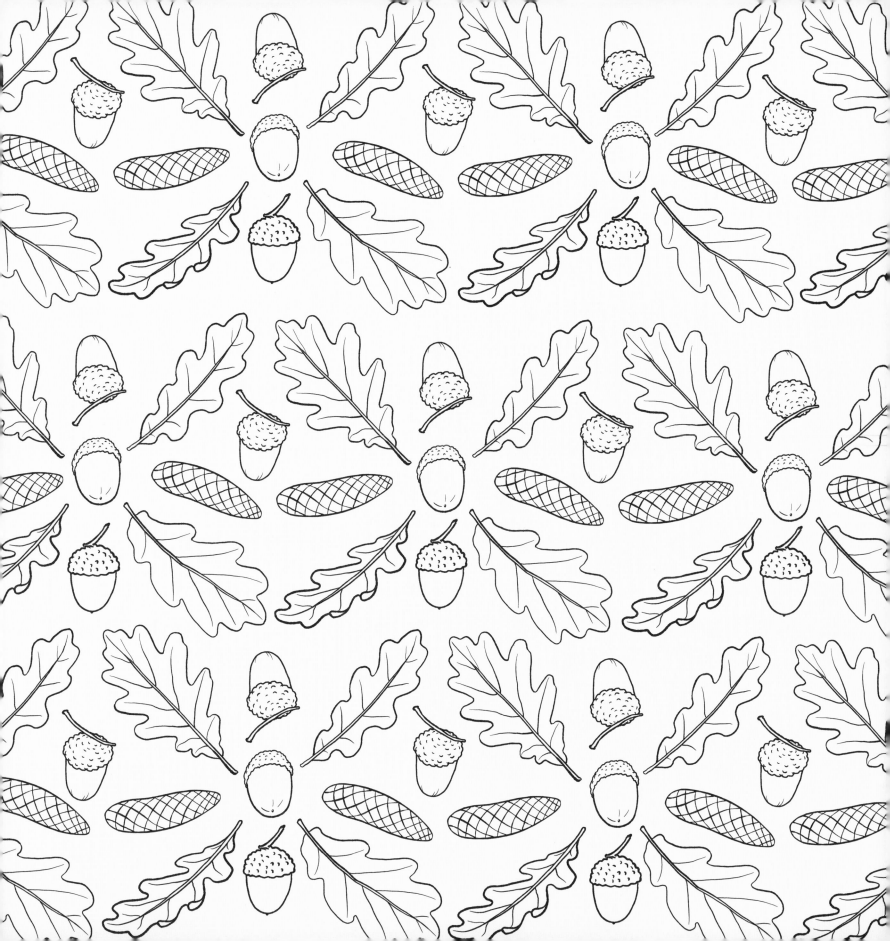

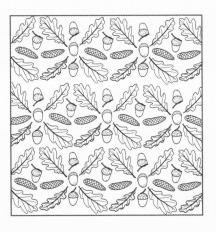

Oak leaves and acorns

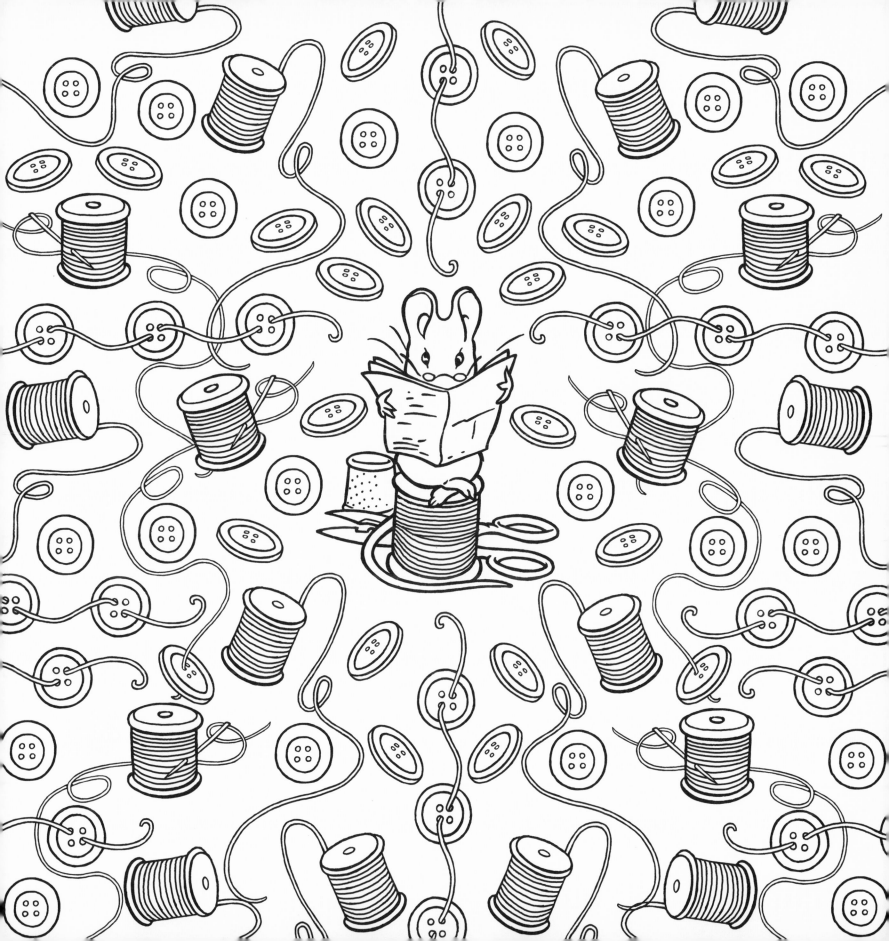

The Tailor of Gloucester

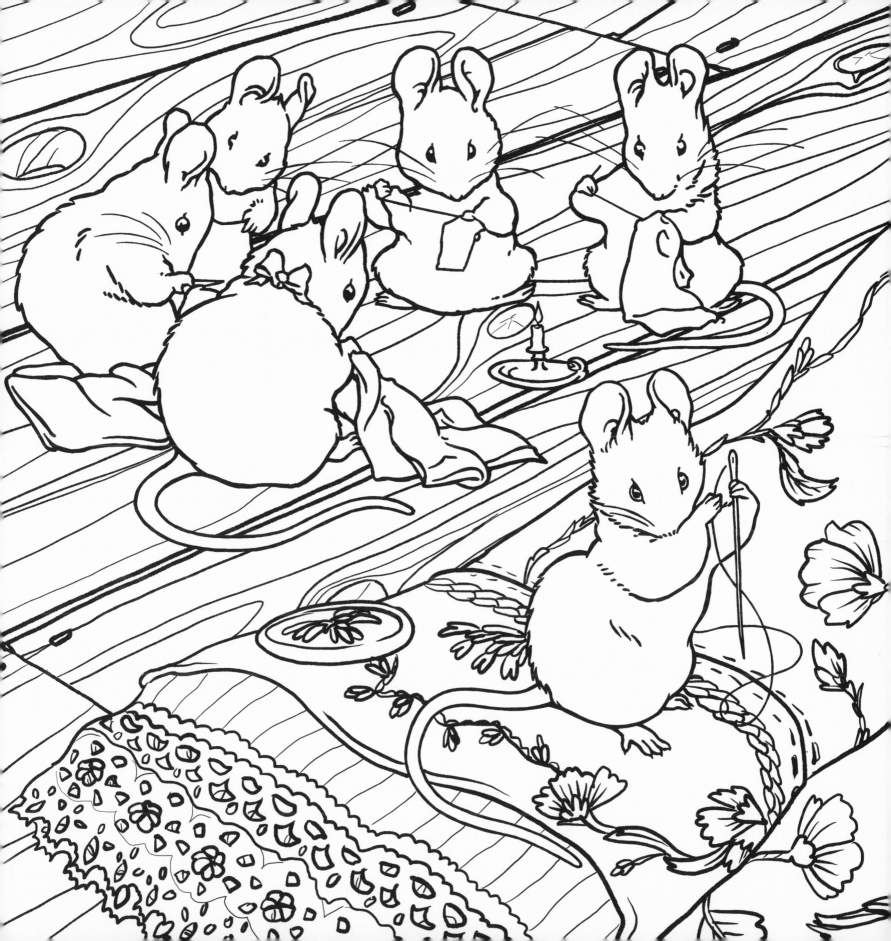

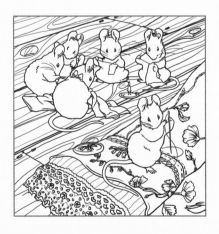

"The stitches of those button-holes were so small – *so* small –
they looked as if they had been made by little mice!"

The Mayor of Gloucester's waistcoat

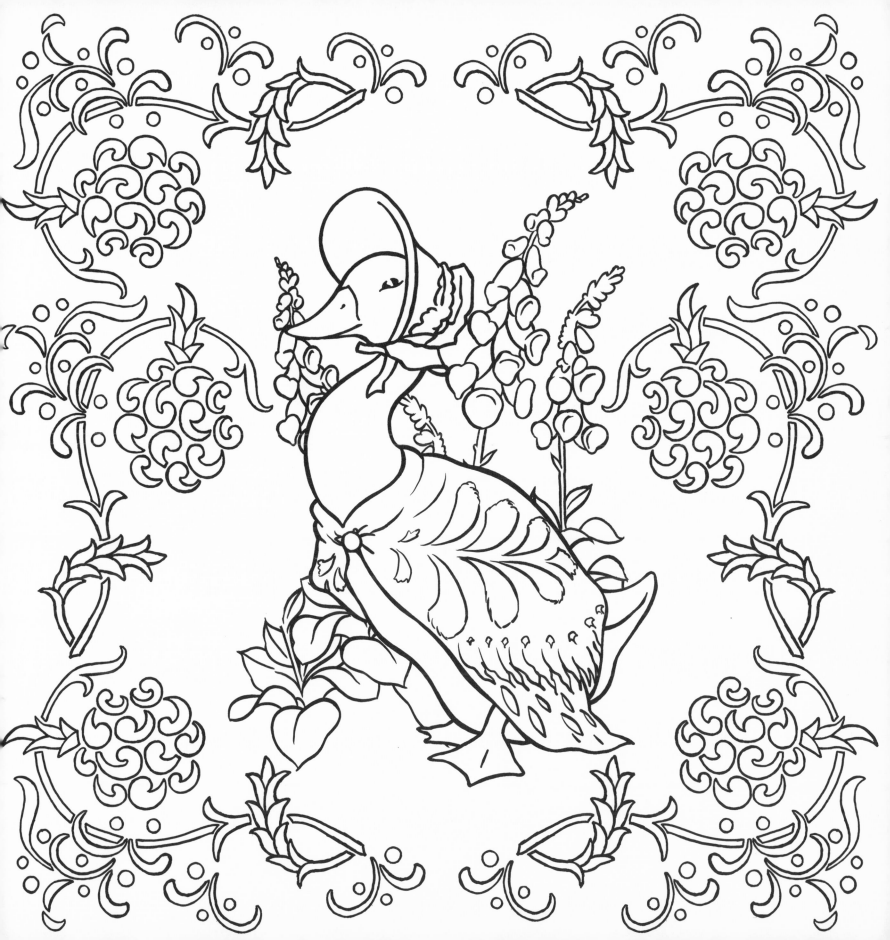

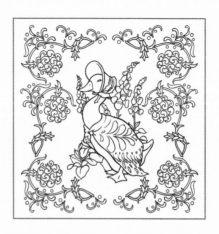

Jemima Puddle-duck

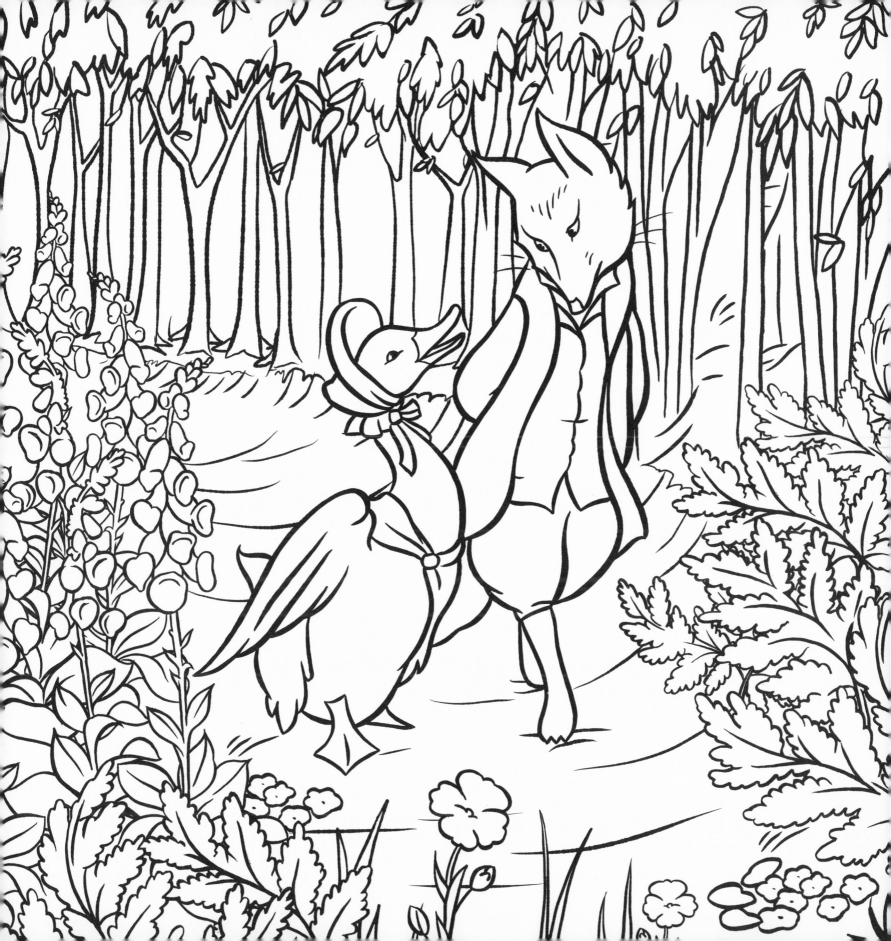

"Jemima thought him mighty civil and handsome."

Floating feathers

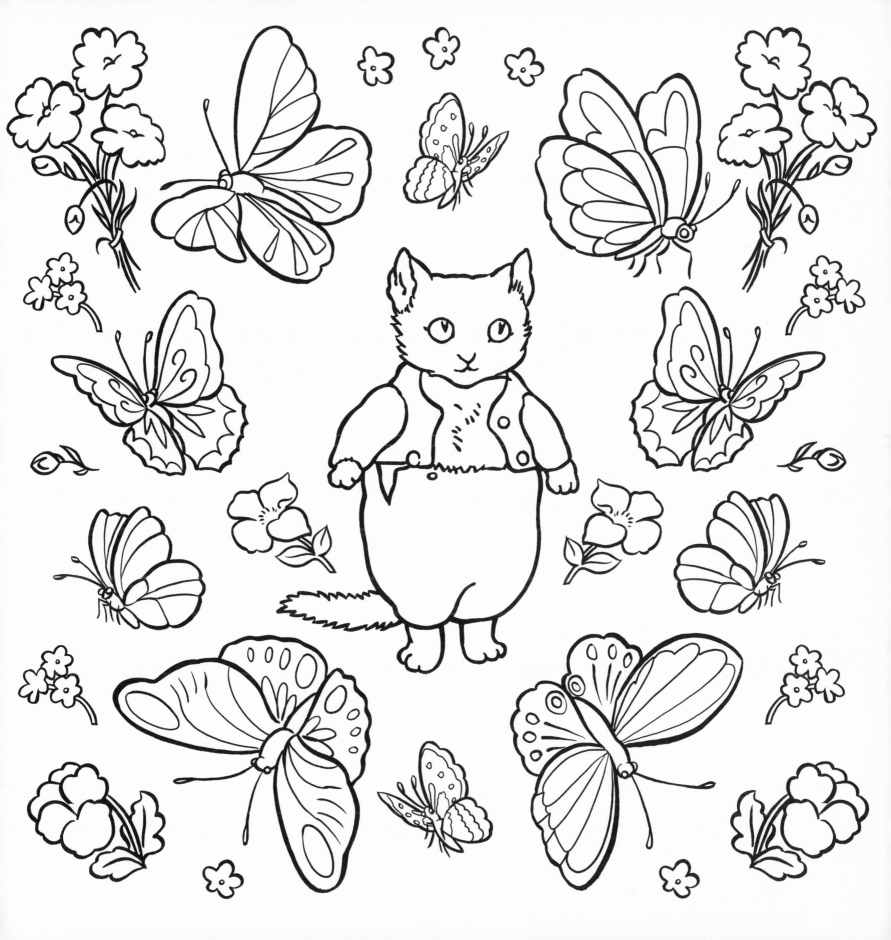

Tom Kitten

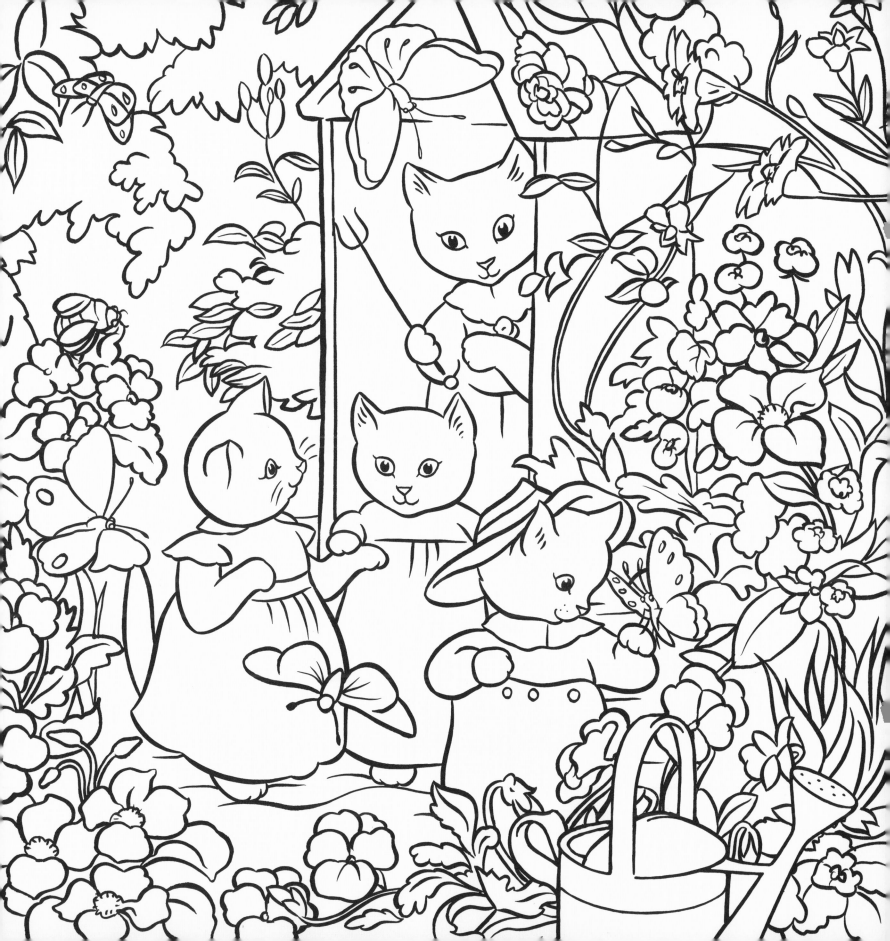

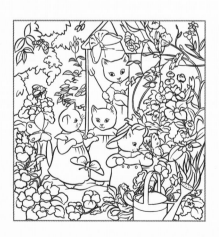

"Once upon a time there were three little kittens,
and their names were – Mittens, Tom Kitten, and Moppet."

Pansies and roses

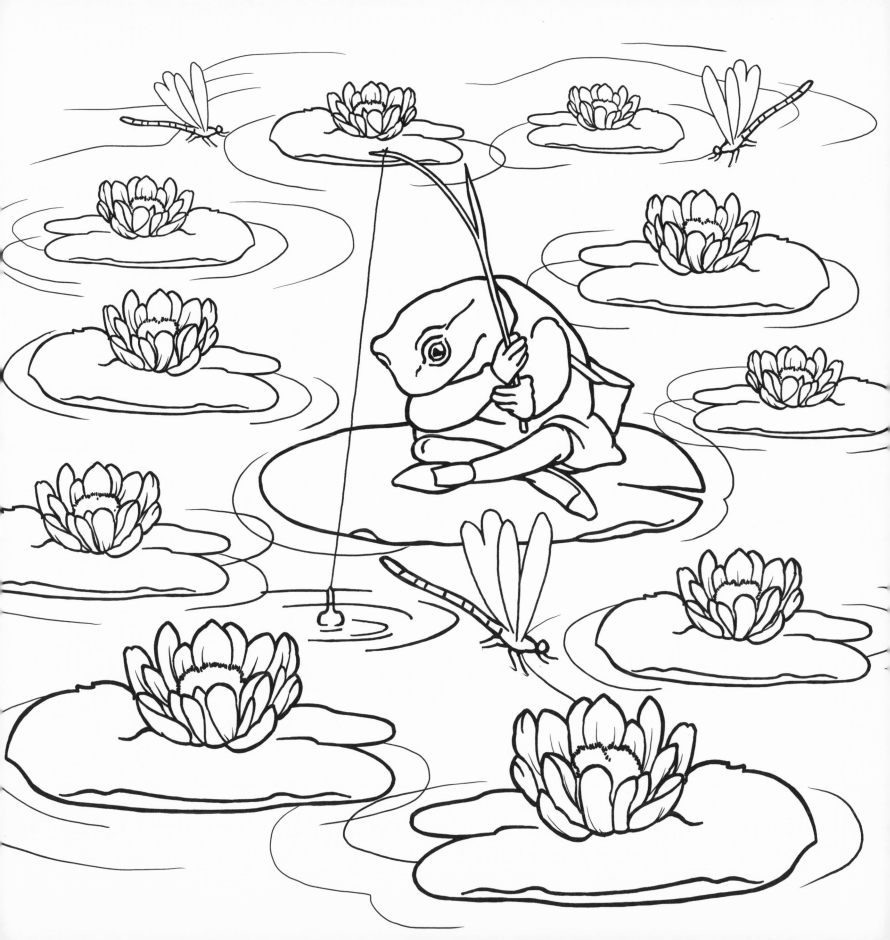

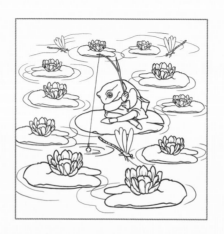

Mr. Jeremy Fisher

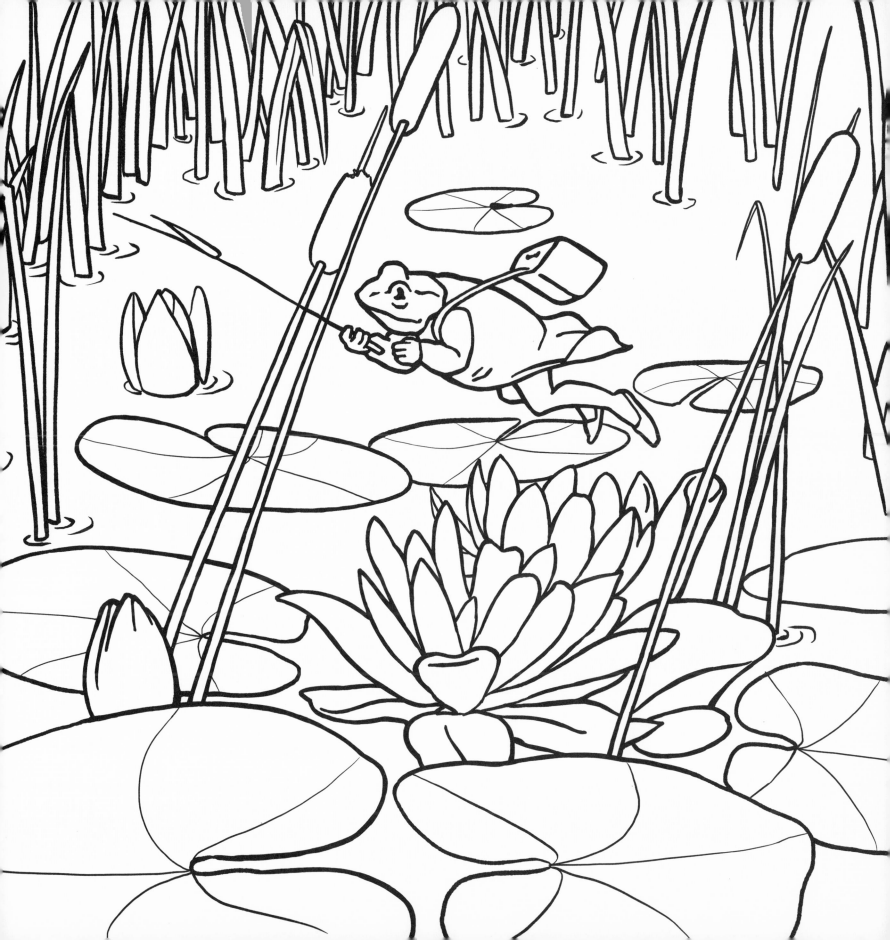

"Mr. Jeremy put on a macintosh and a pair of shiny goloshes..."

Pond life

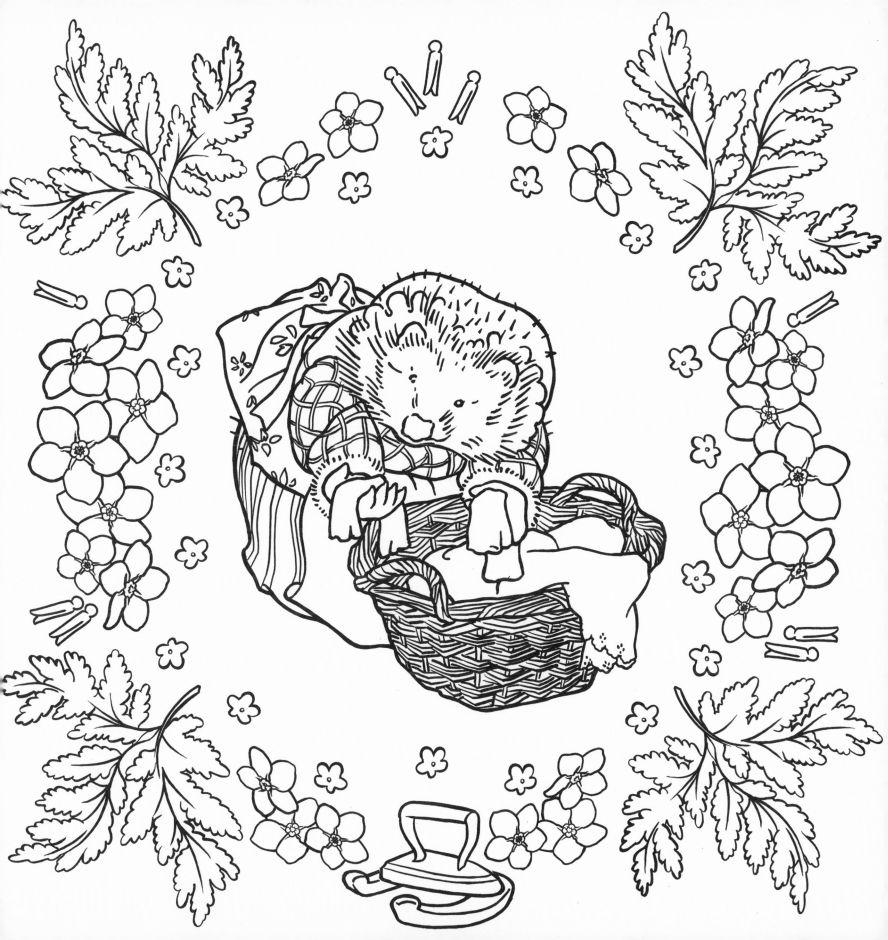

Mrs. Tiggy-winkle

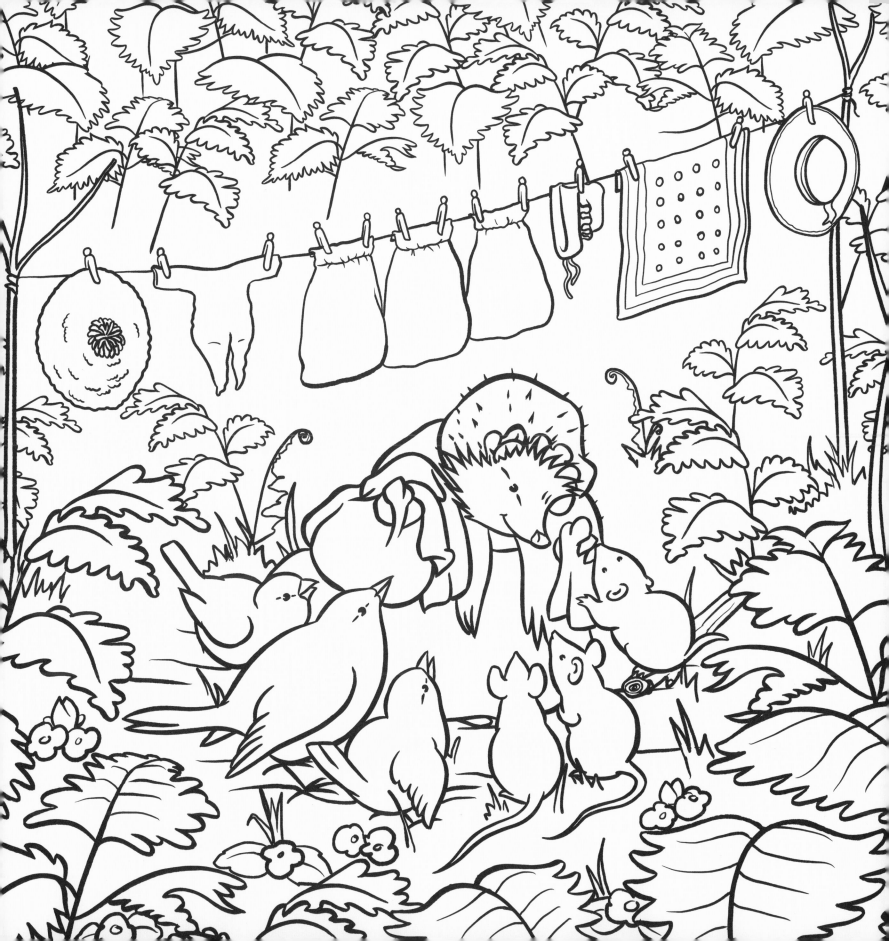

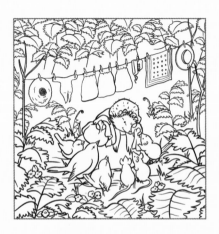

"And she hung up all sorts and sizes of clothes . . ."

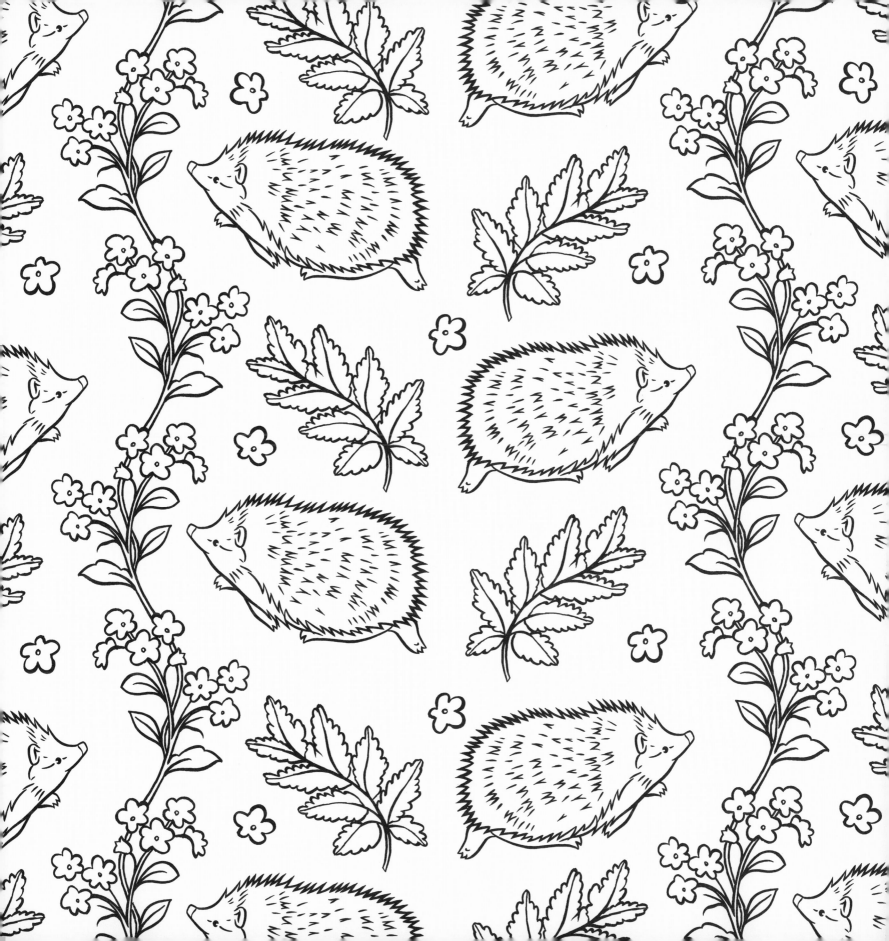

Hedgehogs and forget-me-nots

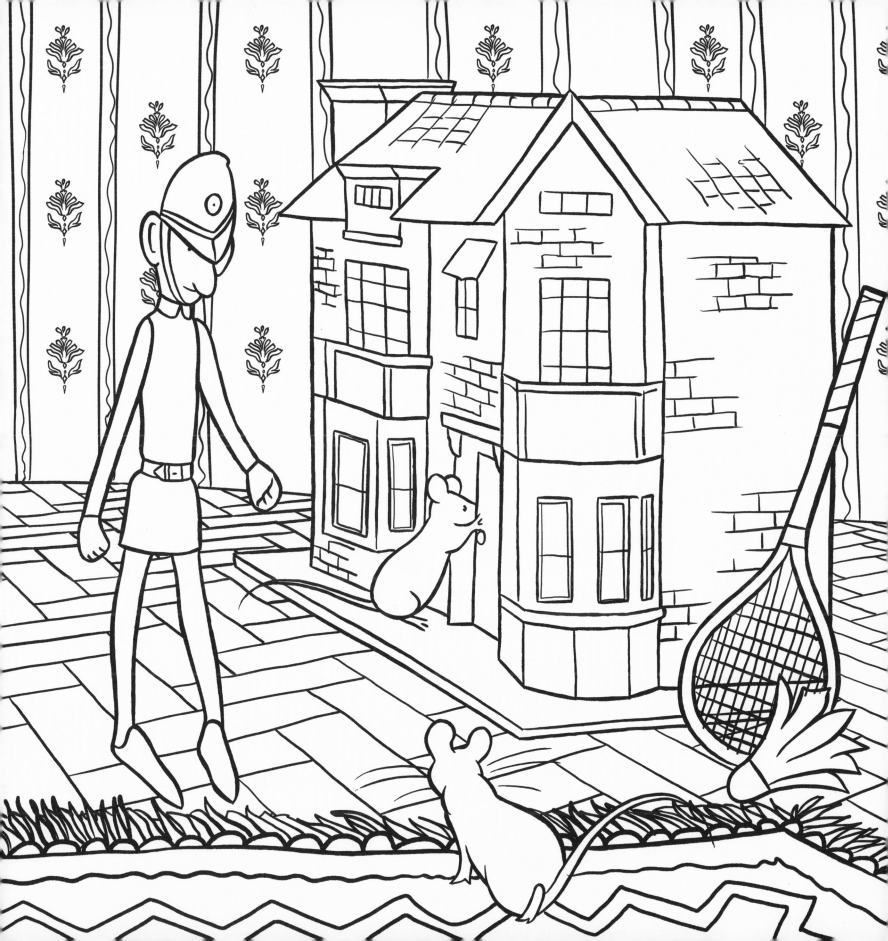

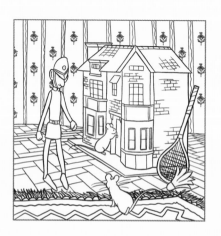

Two bad mice

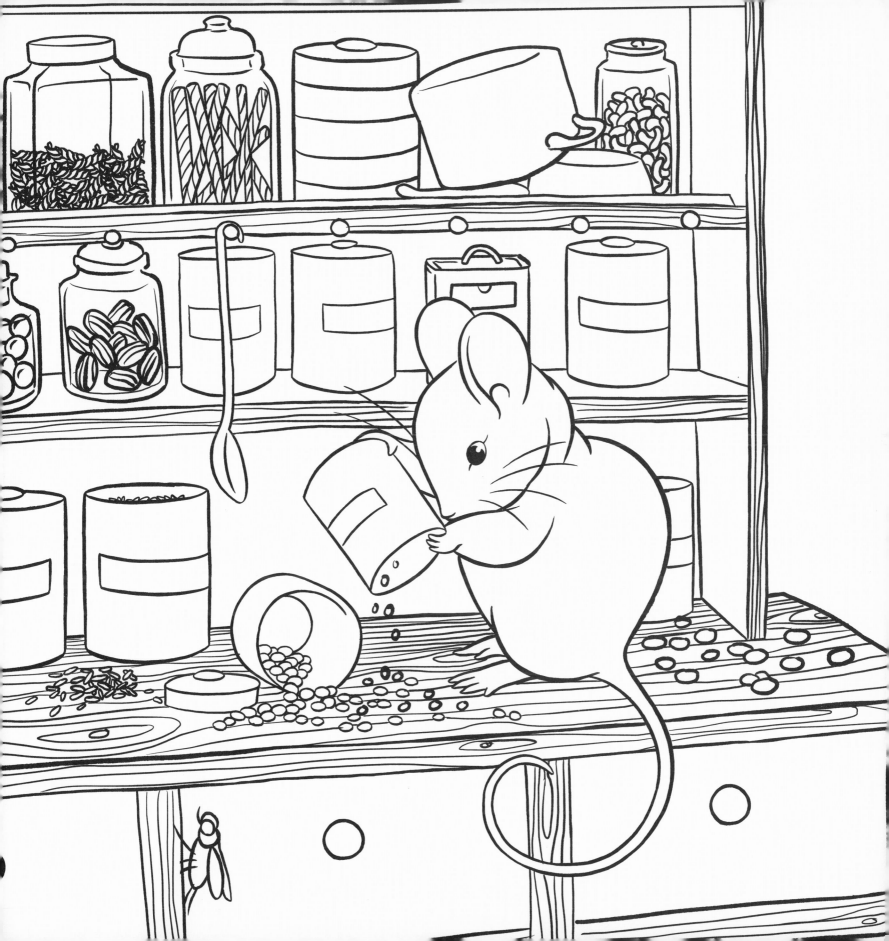

"She found some tiny canisters upon the dresser,
labeled – Rice – Coffee – Sago . . ."

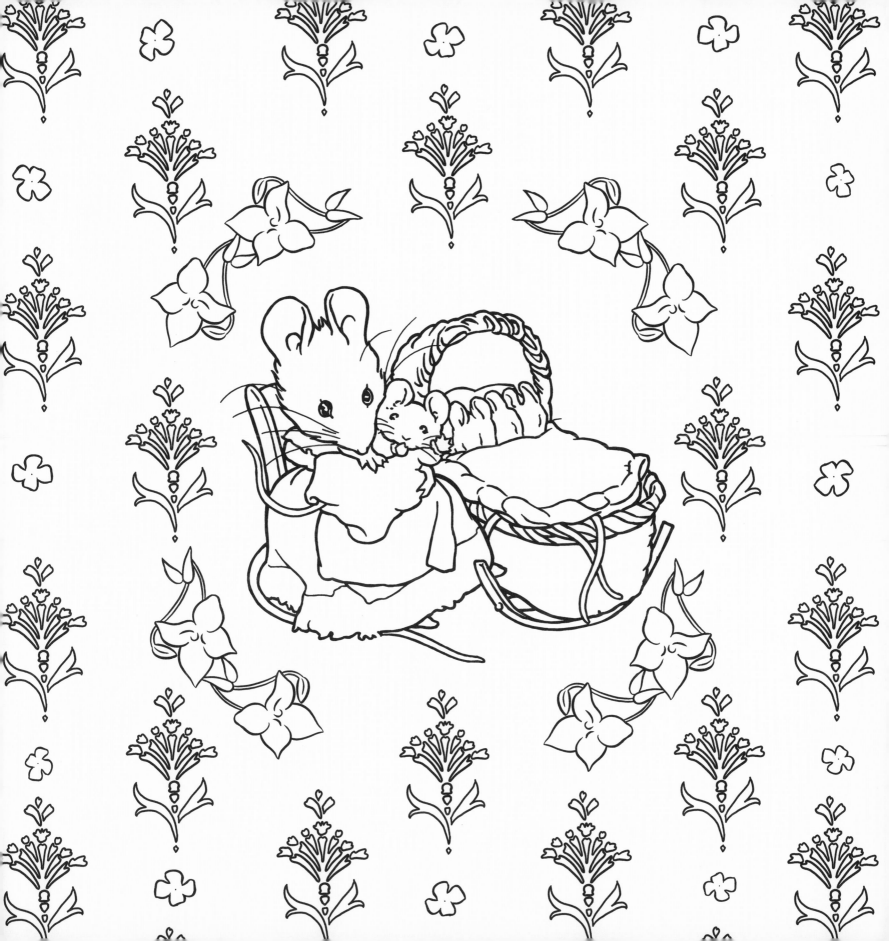

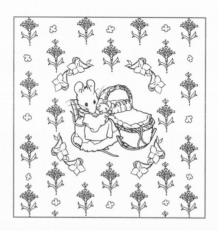

Hunca Munca and the cradle

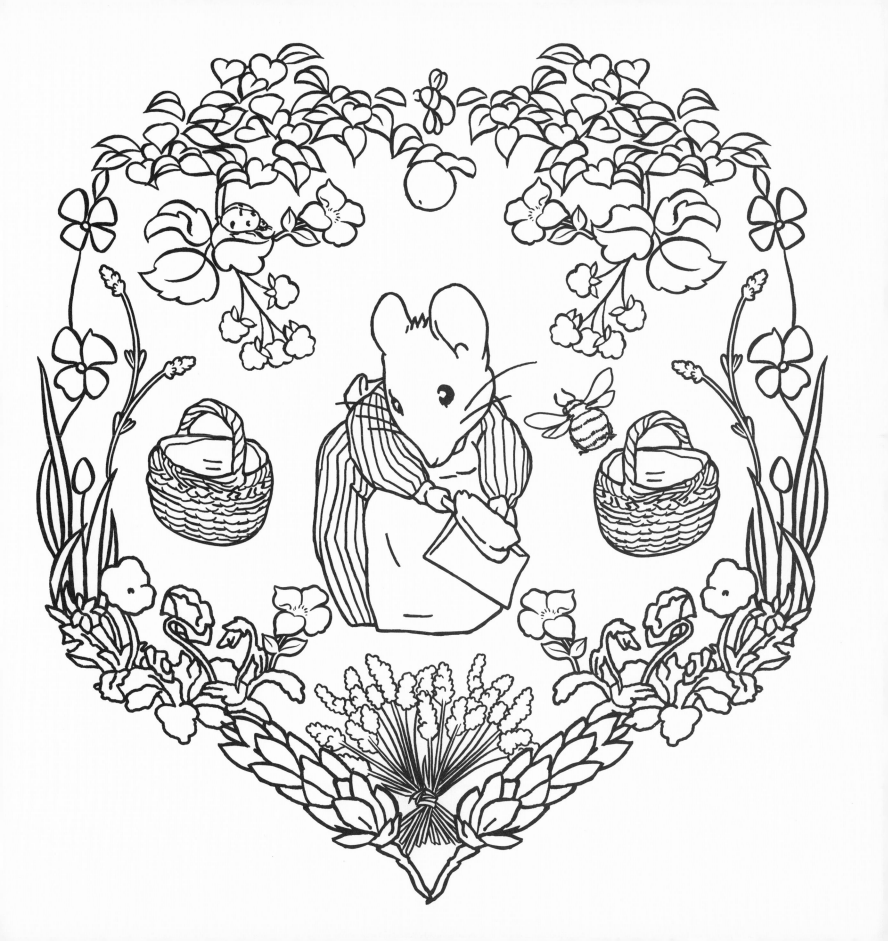

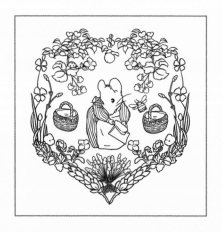

Mrs. Tittlemouse

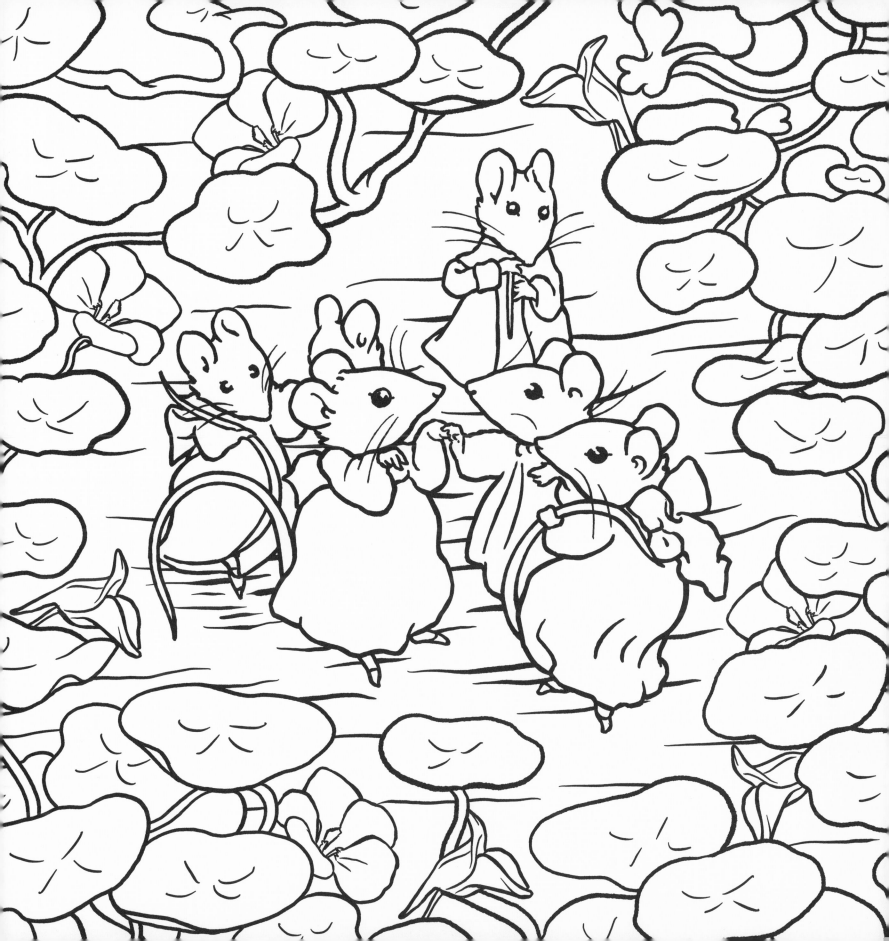

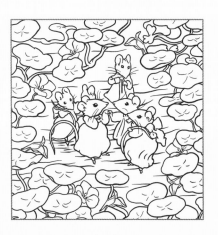

"When it was all beautifully neat and clean,
she gave a party to five other little mice . . ."

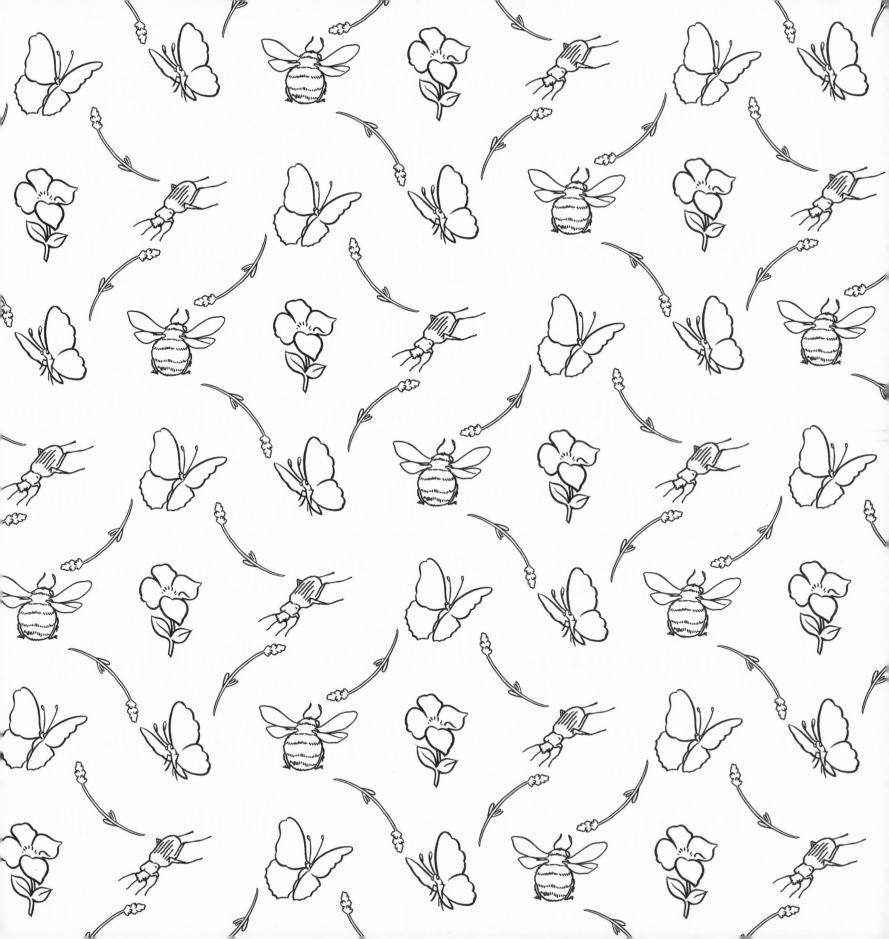

Butterflies, beetles, and bees

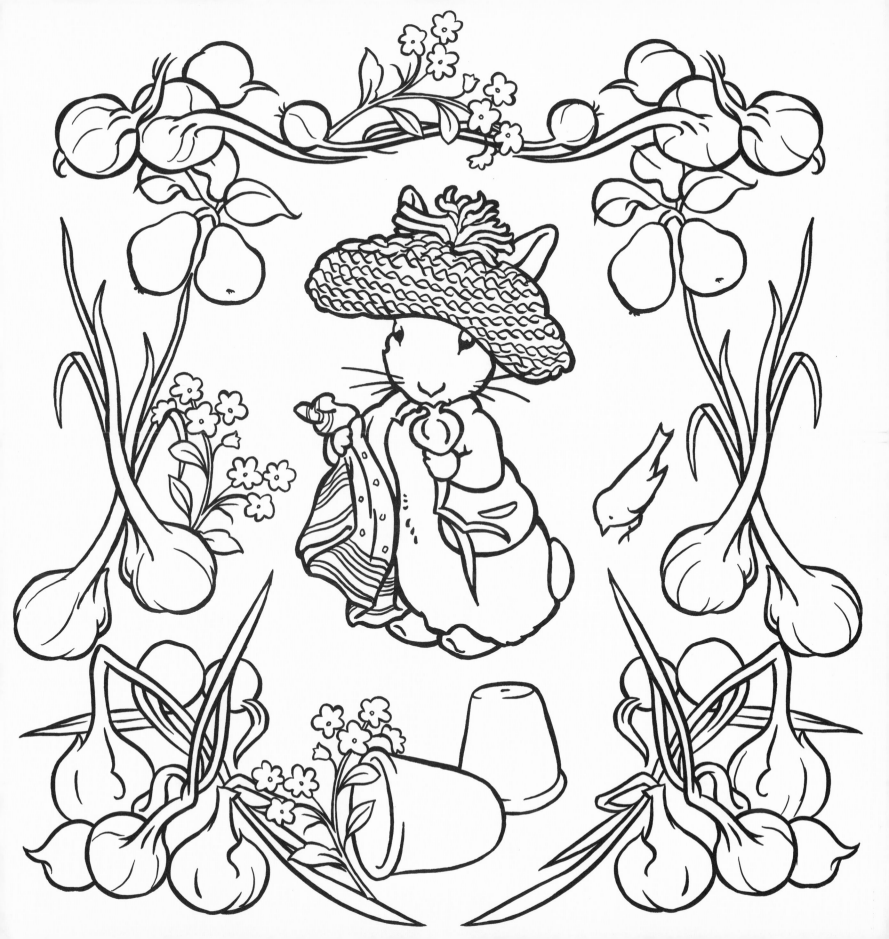

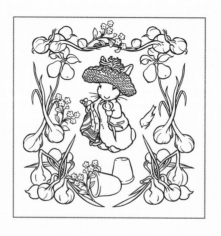

Benjamin Bunny

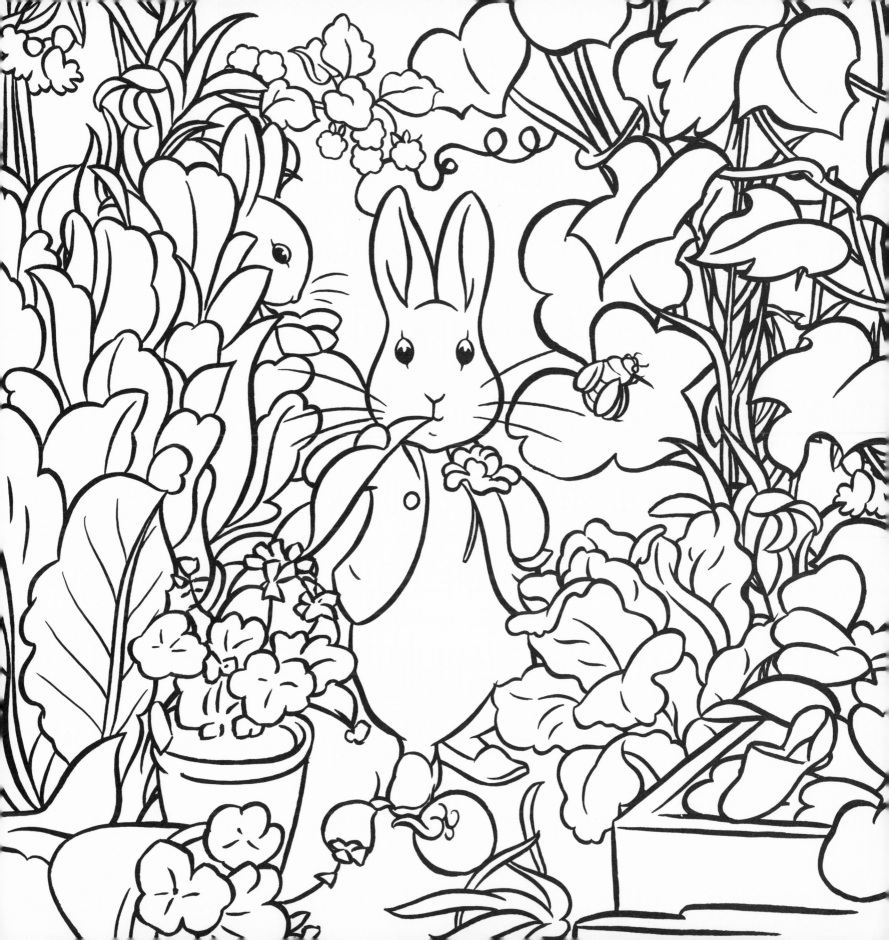

"The lettuces certainly were very fine..."

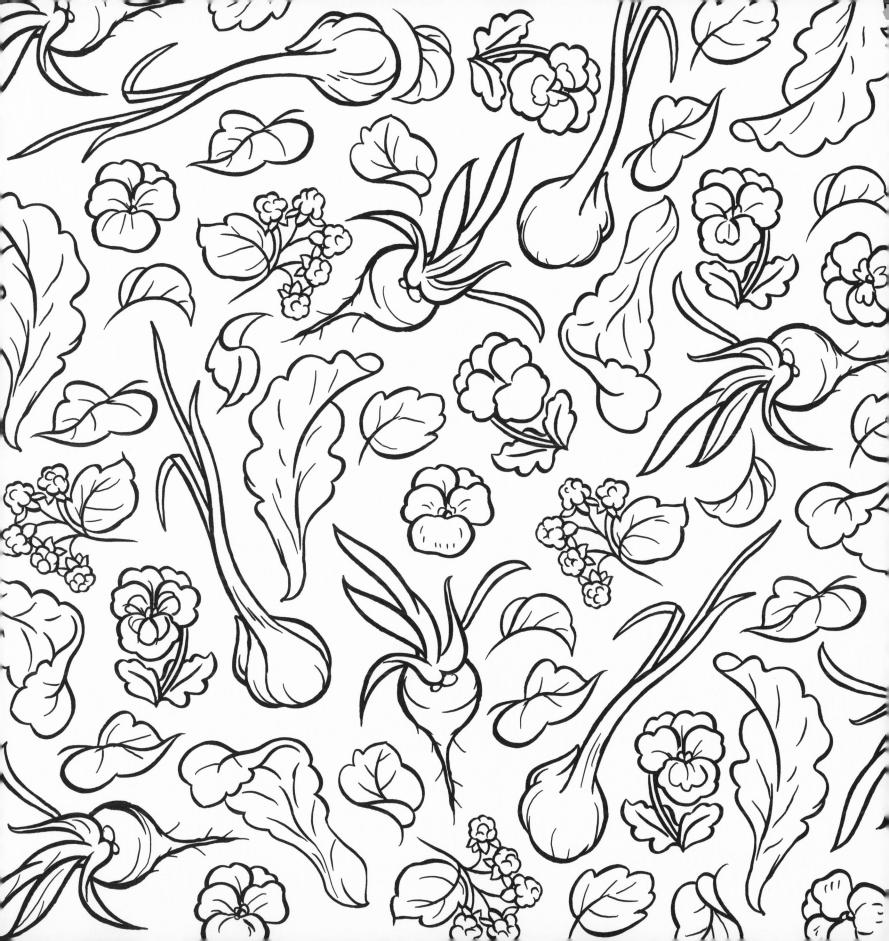

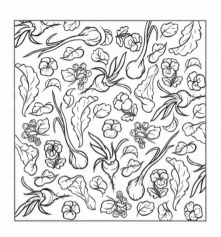

Onions and lettuces

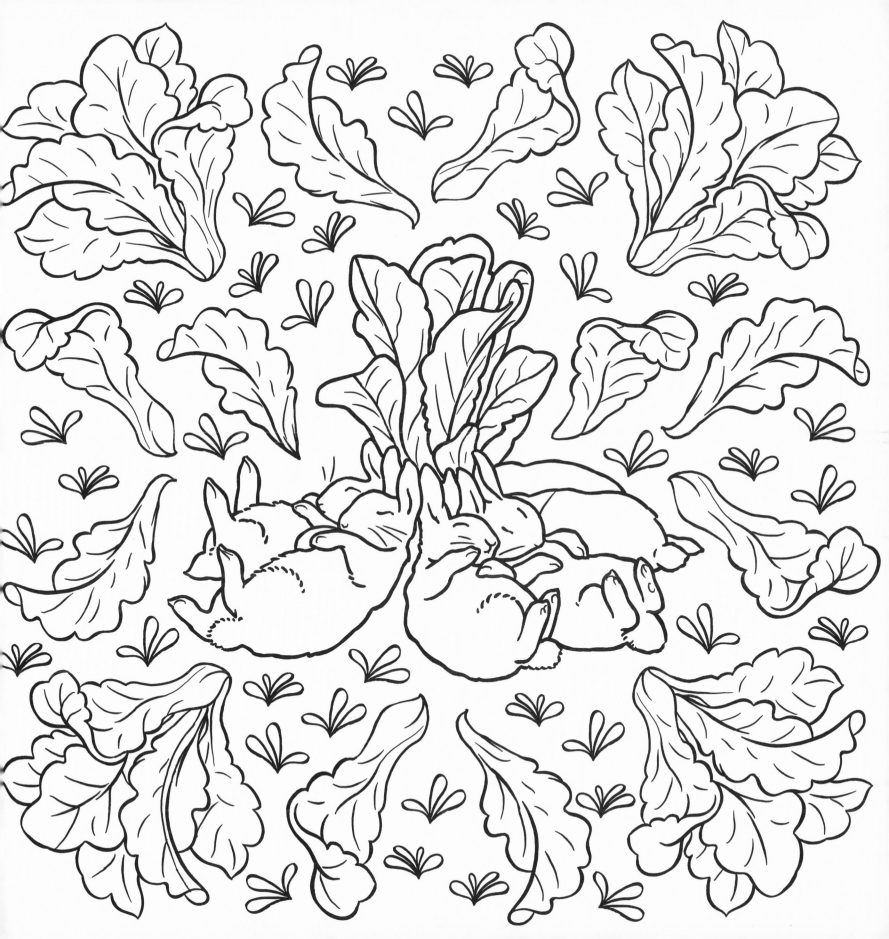

The Flopsy Bunnies

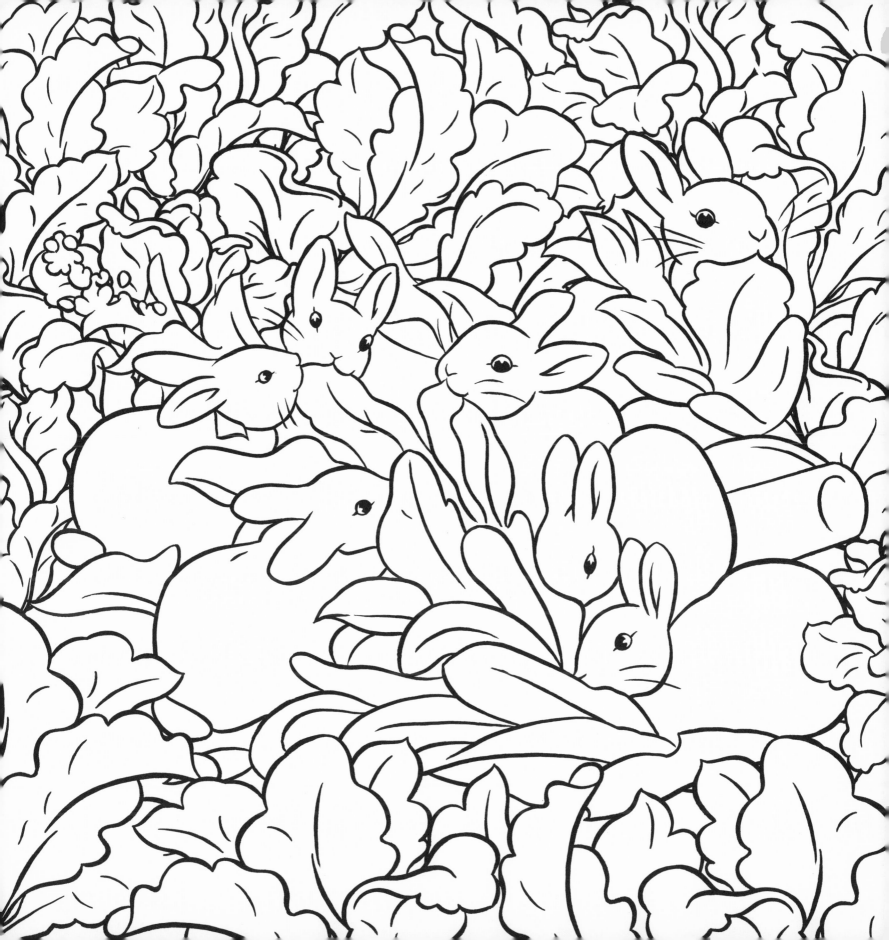

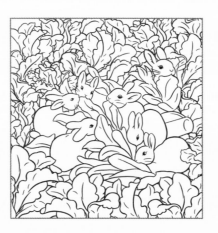

"One day – oh joy! – there were a quantity of overgrown lettuces..."

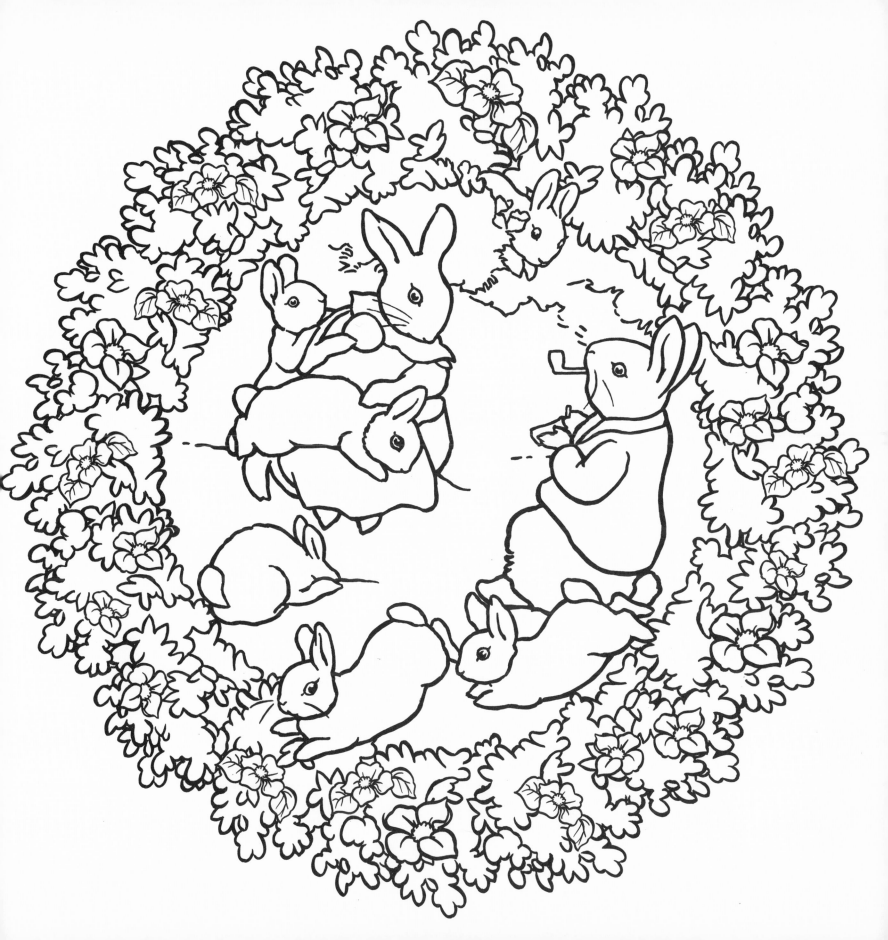

A family affair

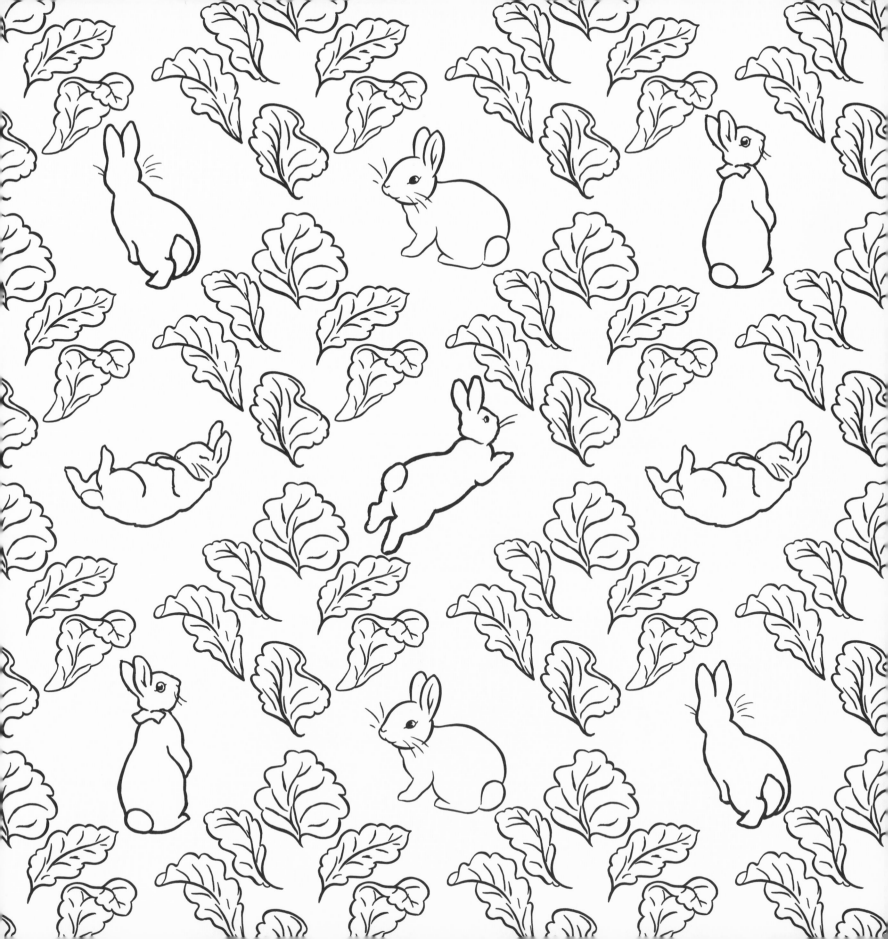

A maze of lettuces

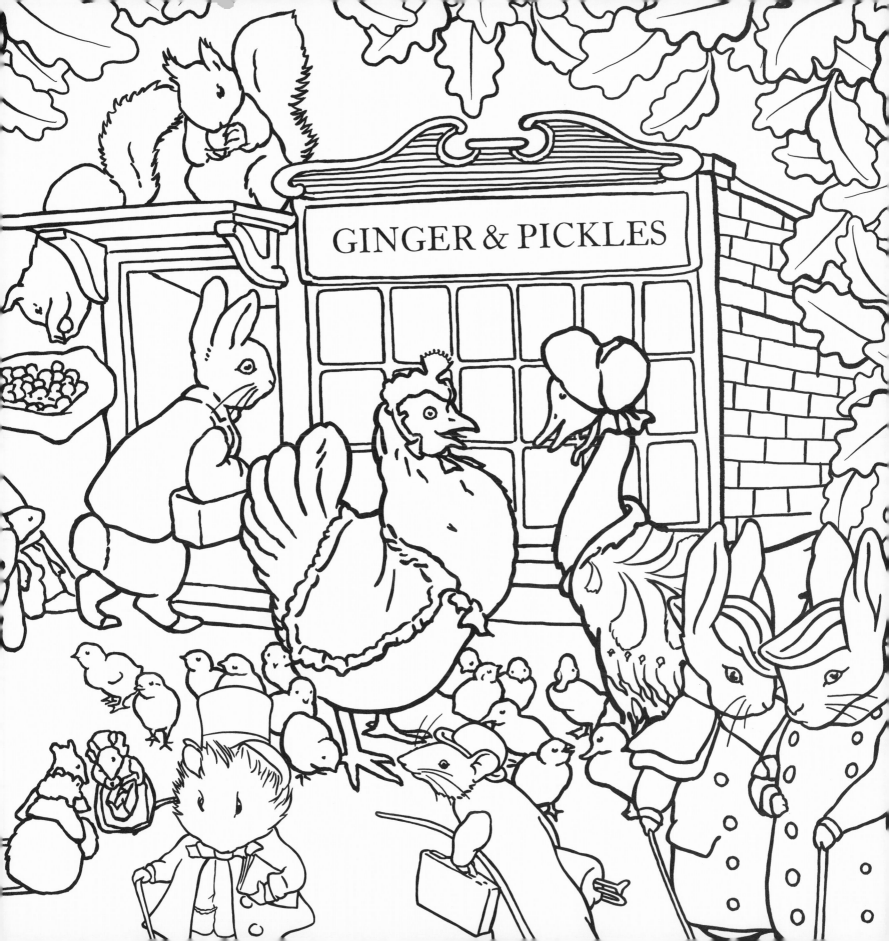

Ginger & Pickles' shop

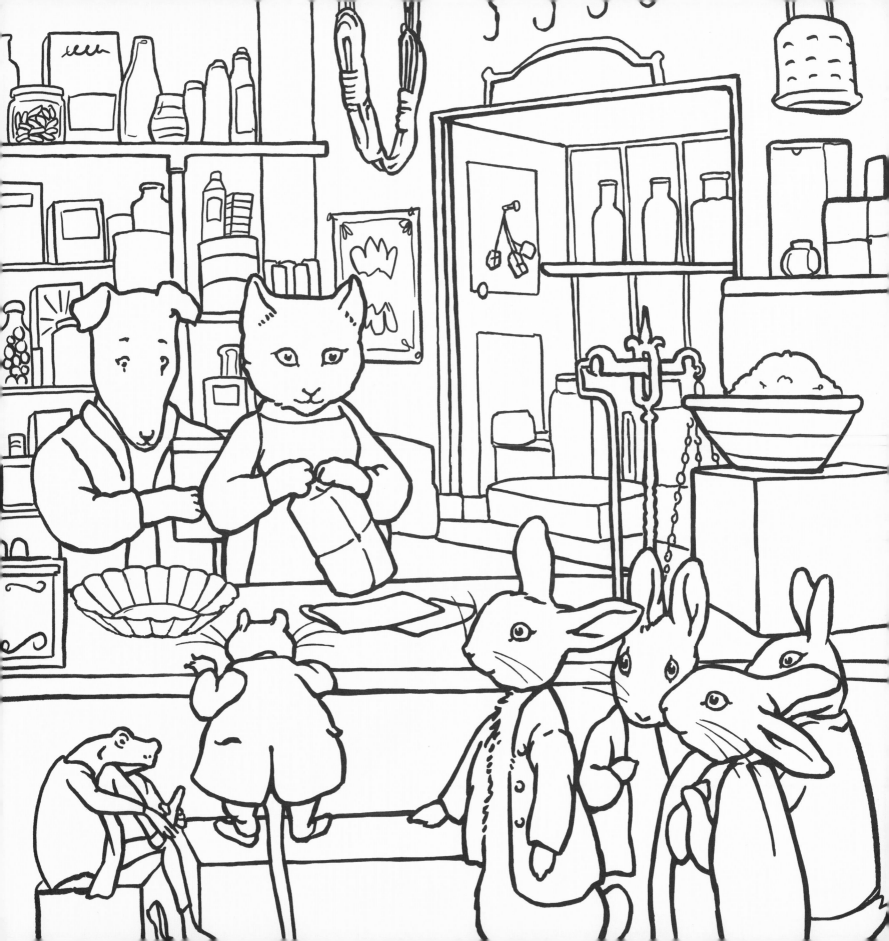

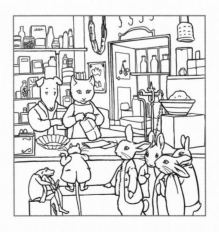

"Ginger was a yellow tom-cat and Pickles was a terrier."

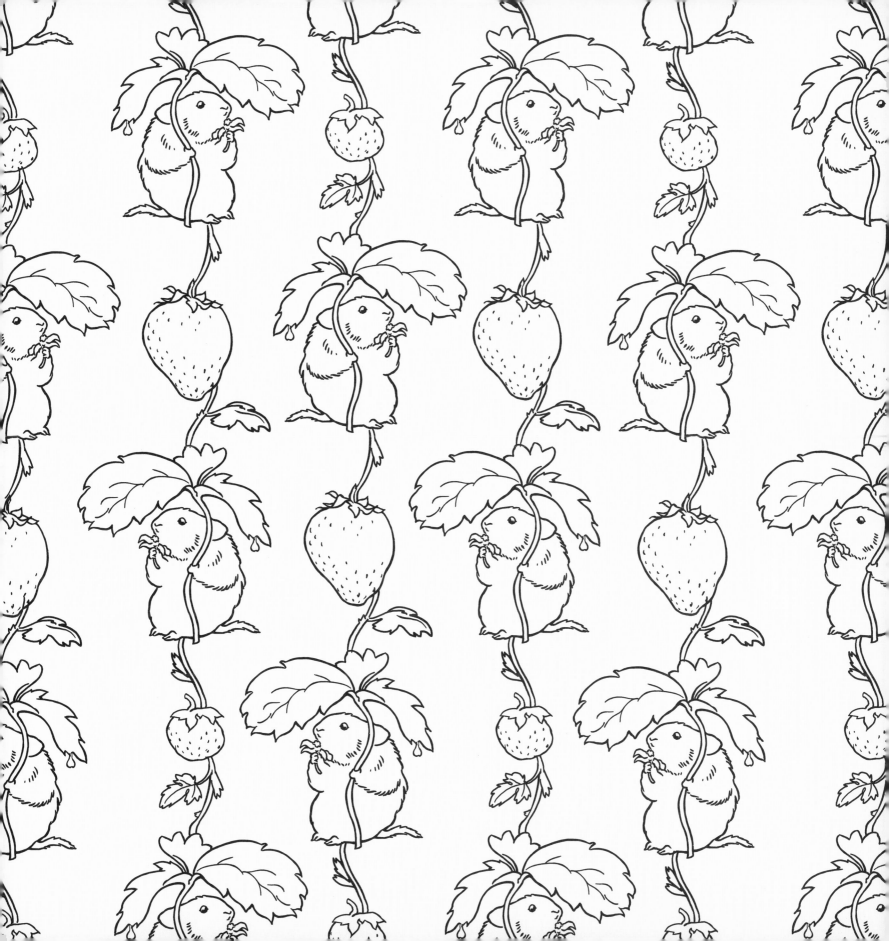

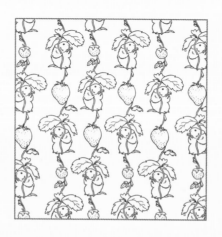

Strawberry shade

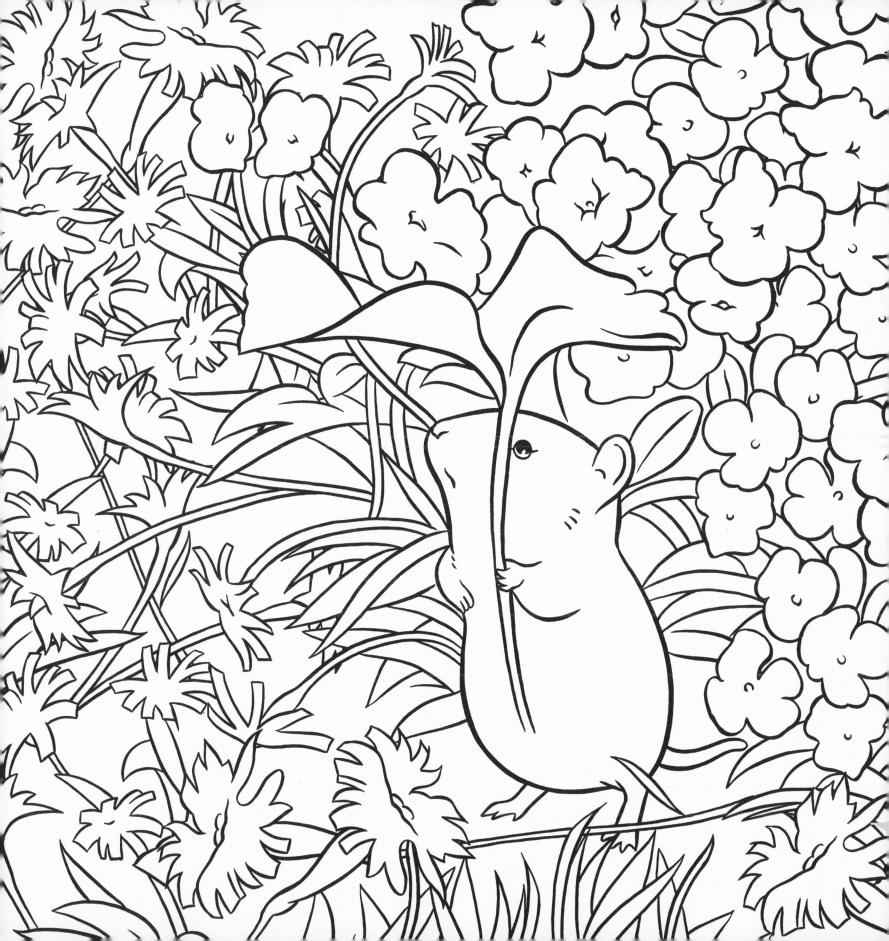

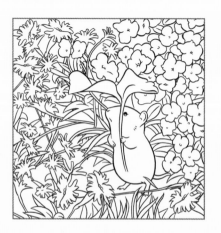

Timmie Willie

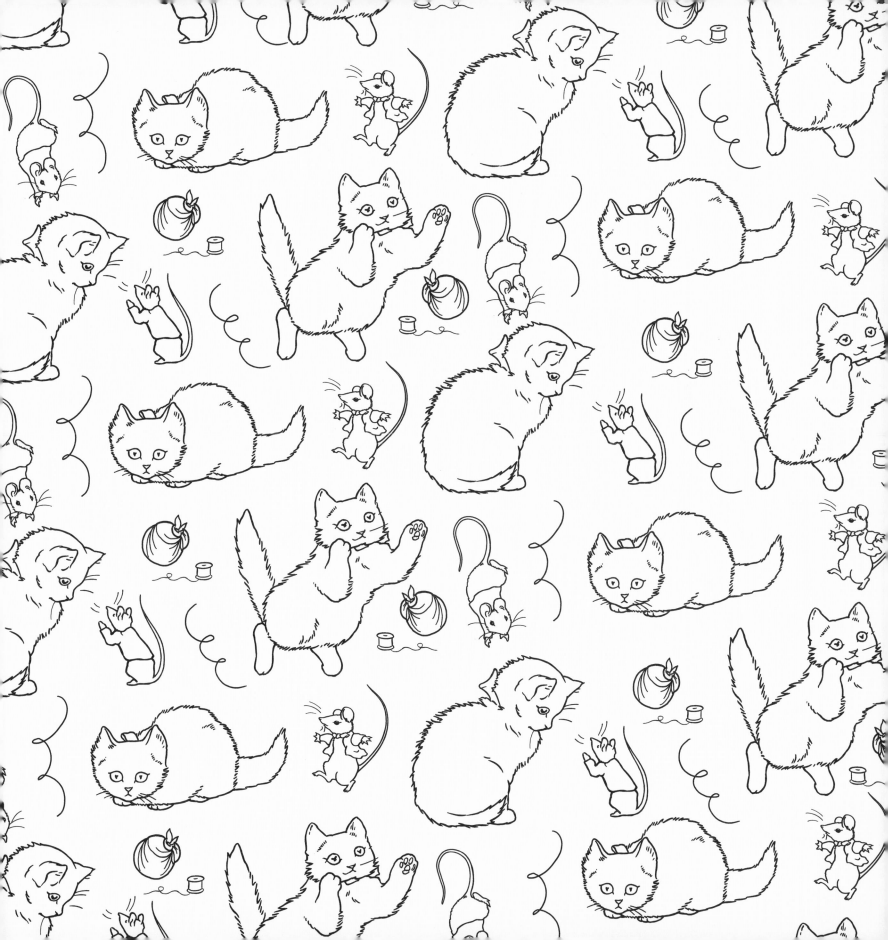

Miss Moppet and the Mouse

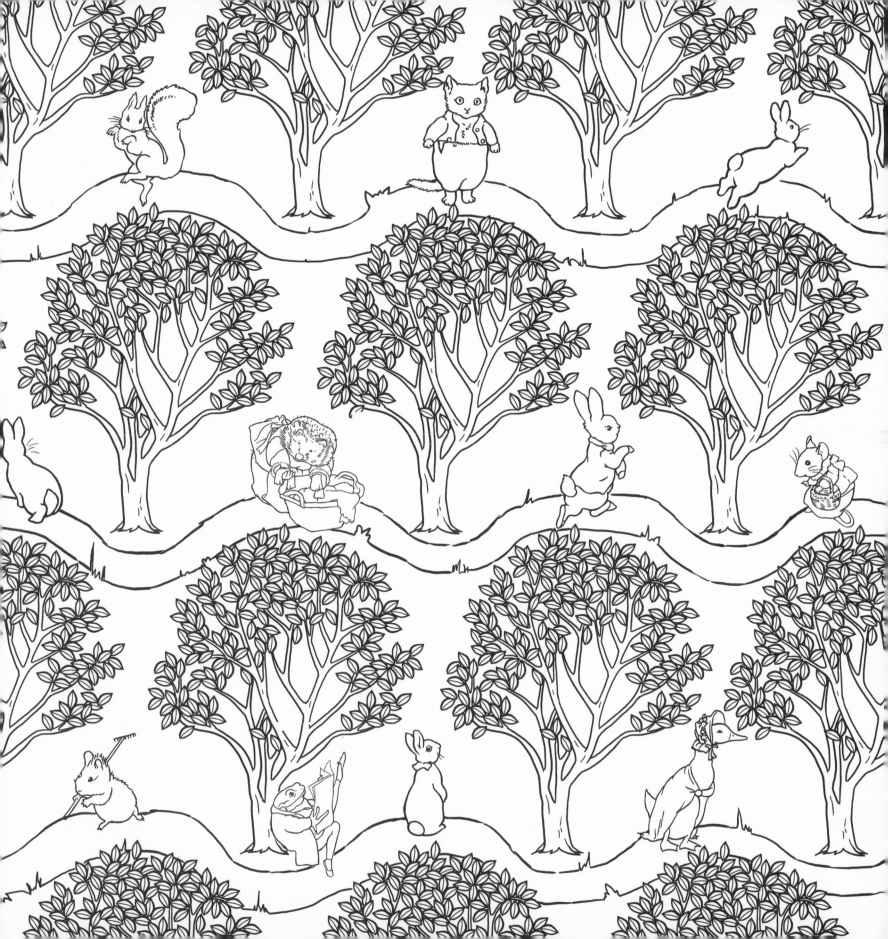

In the woods

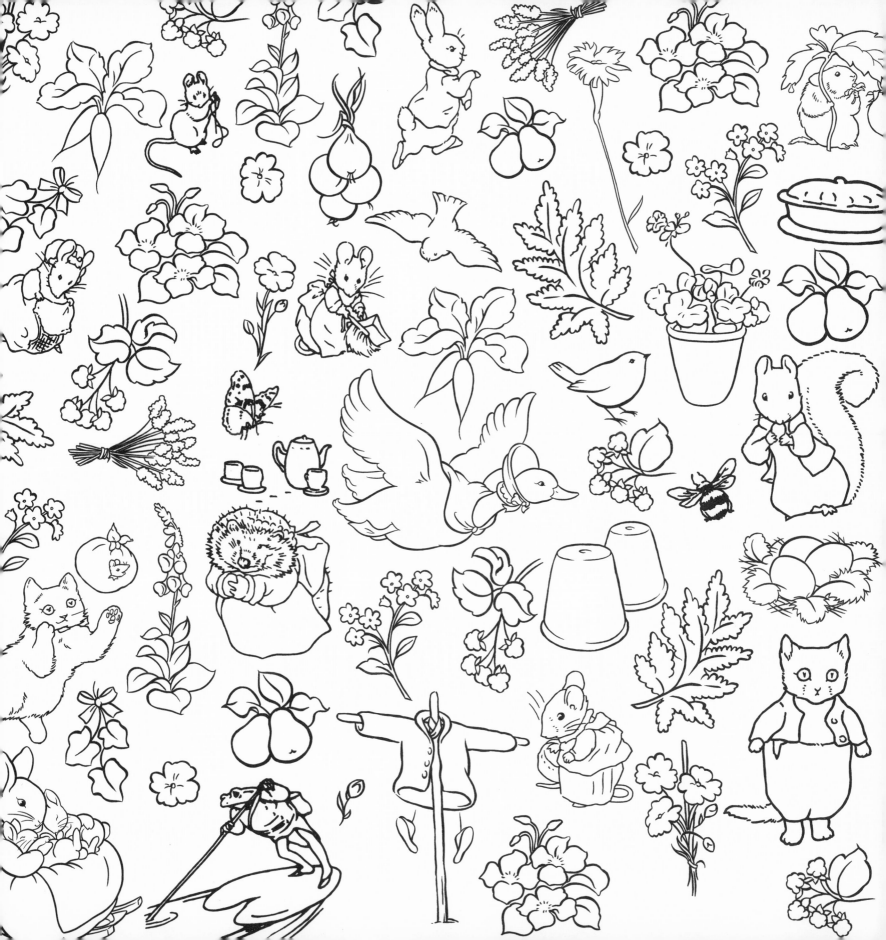

The world of Beatrix Potter